G. Gaeta Bertelà

# Luca, Andrea, Giovanni Della Robbia

**Constable**

London

# Index of Illustrations

## Arezzo

**Monastery of La Verna**

          Andrea Della Robbia
P. 19  Crucifixion
51  Annunciation

## Florence

**Basilica of Santa Croce**

          Luca Della Robbia
P. 4  St. Thomas (Pazzi Chapel)
          Andrea Della Robbia
P. 54  Tabernacle

**Cathedral**

          Luca Della Robbia
P. 37  Resurrection
37  Ascension
40  Angel with Candlestick
41  Head from bronze doors

**Cathedral Museum**

          Luca Della Robbia
P. 25  The Cantoria
Pages 25-33  Cantoria Panels and details
P. 34  Grammar
35  Philosophy, detail
35  Music, Orpheus

**Church of Orsanmichele**

          Luca Della Robbia
P. 11  Emblem of the Guild of Silkworkers
13  Emblem of the Guild of Stonemasons and Woodworkers
48  Emblem of the Guild of Doctors and Apothecaries

**Church of Santissimi Apostoli**

          Giovanni Della Robbia
P. 60  Tabernacle

**Church of San Gaetano**

          Luca Della Robbia (?)
P. 10  Madonna and Child

**Church of Santa Maria Novella**

          Giovanni Della Robbia
P. 59  Lavabo (Sacristy)

**Church of San Miniato**
**(Chapel of the Cardinal of Portugal)**

          Luca Della Robbia
P. 46  Fortitude
47  Decoration of the ceiling

**Church of Santa Trinita**

          Luca Della Robbia
P. 8  Tomb of Bishop Federighi, detail
Pages 44-45  Tomb of Bishop Federighi

**Hospital of the Innocents**

          Luca Della Robbia
P. 43  Madonna of the Innocents
          Andrea Della Robbia
P. 50  Putto
51  Annunciation

**Hospital of St. Paul**

          Andrea Della Robbia
P. 52  Meeting Between St. Francis and St. Dominic

**National Museum (Bargello)**

          Luca Della Robbia
P. 15  Madonna of Via dell'Agnolo
36  Deliverance of St. Peter
36  Crucifixion of St. Peter
38  Madonna of the Apple
39  Madonna of the Rosegarden
42  Madonna of Santa Maria Nuova
          Andrea Della Robbia
P. 17  Adoration
20  Madonna of the Architects
55  Portrait of a Boy
56  Portrait of a Lady
57  Madonna of the Cushion
58  Portrait of an Unknown Girl
          Giovanni Della Robbia
P. 23  Adoration
61  Deposition
61  Ascension
62  St. Ursula
63  Medici-Bartolini Salimbeni Tondo

## Impruneta (Florence)

**Church of Santa Maria**

          Luca Della Robbia
P. 49  Crucifixion

## Peretola (Florence)

**Church of Santa Maria**

          Luca Della Robbia
P. 6  Tabernacle

## Pistoia

**Church of San Giovanni Fuorcivitas**

          Andrea Della Robbia
P. 53  Visitation

**Hospital 'del Ceppo'**

          Giovanni Della Robbia
P. 64  « Visit the Sick »

# Luca, Andrea, Giovanni Della Robbia

The work of the Della Robbia family constitutes a unique chapter in the history of Renaissance art. Their activity extended over a long period of time and epitomized distinct phases in the development of the Renaissance, taking on different characteristics according to whether the head of the workshop was Luca, Andrea or Giovanni.

Sources concerning Luca, the oldest of the three masters, are often inaccurate and incomplete. According to Vasari, the sculptor was born "in the year 1388 in the house of his ancestors, near the church of San Barnaba in Florence. There he was raised until he had learnt not only reading and writing but also arithmetic, according to his needs, as was customary for most Florentines at the time. And after that his father apprenticed him to the goldsmith Leonardo di Ser Giovanni, at that time considered the best goldsmith in Florence."

It is likely that Vasari was correct in affirming that Luca received his first artistic training in the goldsmith's art, as was common among young Florentine apprentices during the Renaissance. It is less likely, however, that his teacher was Leonardo di Ser Giovanni, a goldsmith who was active between 1360 and 1380, and who was quite probably dead by around 1420 when Luca began his brilliant career.

pages 25-33

The first document from which we can reconstruct Luca's artistic career is the commission of 1431 from the Opera del Duomo for a *Cantoria* (a Singing Gallery) to be placed above the door of the North Sacristy of the Cathedral of Florence. Luca's *Cantoria* reflects the serenity which we associate with the classical Greek world and which is fundamental to his extraordinarily limpid and direct form of expression.

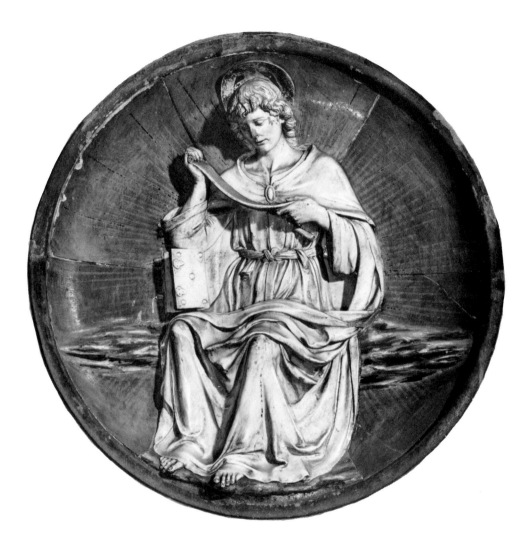

LUCA DELLA ROBBIA
(1440-1450; 4'4" diam.;
enameled terracotta)
St. Thomas
Pazzi Chapel, Santa Croce
Florence

With the completion of the *Cantoria* in about 1438-1439, it was already clear that Luca did not participate entirely in the contemporary artistic tendencies which were being formulated by Masaccio, Brunelleschi, Donatello, Iacopo della Quercia and Ghiberti. His art was constantly inspired by an intellectual ideal of formal purity to be attained through the rhythm of the line and the classically composed volumes; and he seems to have remained untouched by the Renaissance ideas which were already in full development by the 1430s.

It would be difficult, in fact, to find any correlation between Luca's *Cantoria* and the *Cantoria* Donatello was working on at the same time for the door of the South Sacristy of the Cathedral. A comparison of the two works is facilitated by their present collocation: at the end of the 19th century the two *Cantorie* were reassembled and placed opposite each other in the Cathedral Museum in Florence. It is easy to measure the distance which at that moment separated Luca's world from the new culture which had already taken root, and to predict that Luca's future evolution would be in some ways alien to that culture.

Unfortunately, the *Cantoria* has been moved at various times: for the wedding of Ferdinando de' Medici and Violante Beatrice of Bavaria in 1688, it was removed from the Cathedral and replaced by an imposing Baroque *Cantoria* in wood. Luca's *Cantoria* was taken apart and relegated to the storage room of the Cathedral, where it remained until 1883, when it was placed in the museum. During these moves, some parts of its architectural structure were lost, as well as the two angels holding gilt bronze candles, which probably stood above the *Cantoria*. (These angels are now in the Musée Jacquemart-André in Paris.) In the relief panels boys and girls sing and play various instruments in accompaniment to Psalm 150: "Laudate Dominum in sanctis eius; laudate eum in firmamentum virtutis eius" (Praise God in his sanctuary: praise him in the firmament of his power). These panels give the distinct impression that Luca had indeed studied the revolutionary works of the other Florentine sculptors, but that he had absorbed from them only those stylistic innovations and expressive effects which were congenial to his profound aspiration to give form to an ideal of serene, Olympian composure. For example, Luca makes use of the rich, sculptural effects of Nanni di Banco, of the soft chiaroscuro of Iacopo della Quercia, of Lorenzo Ghiberti's elegance and of Michelozzo's serene harmony of proportions; he uses these elements to create a calm, exquisitely harmonious environment, enhanced by the classical serenity of the faces, by the gentle folds of the drapery and the subtle creation

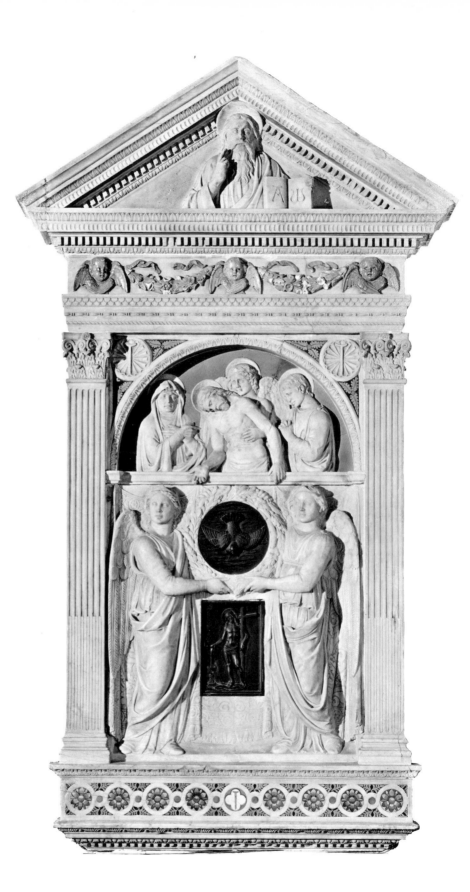

LUCA DELLA ROBBIA
(1441-1443; marble and
enameled terracotta)
Tabernacle
Church of Santa Maria
Peretola (Florence)

6

of depth through lighting. We must also notice the way in which the figurative parts are perfectly related to their architectural framework. Whereas in Donatello's *Cantoria* the wild dance of the putti unfolds without interruption behind the row of colonnets which accentuate the lively chiaroscuro of the figures, in Luca's the architectural divisions rhythmically scan the space with a geometrical precision that recalls Brunelleschi, creating an exceptional balance of forms. And where Donatello's work is enriched with gleaming reflections of gold and color, Luca adheres to a monochrome scheme as though to underline more clearly that "classical" sculptural form is better achieved with simple compositional elements.

pages 34-35

The decoration of the north side of Giotto's Bell Tower (1437-1439) was probably carried out while he was also working on the *Cantoria*. Luca made five hexagonal relief panels representing the *Liberal Arts*, in completion of the series begun by Andrea Pisano: "In the first panel Luca portrayed Donatus teaching Grammar; in the second Plato and Aristotle for Philosophy; in the third a man playing the lute for Music; in the fourth Ptolemy for Astrology and in the fifth Euclid for Geometry." These panels mark an important phase in the artist's development. Traces of Tuscan Gothic motifs, although "modernized," are still retained, as though Luca had not wanted his panels to differ too much from Andrea Pisano's. But at the same time we notice the sober clarity of the planes and rhythms, which were to become constant qualities of his art. Also evident are certain elements which denote the influence of Donatello, particularly in the scenes with more than one figure.

page 36

The commission for the two marble altars of St. Peter and St. Paul for the gallery of the church of San Zanobi also belongs to this same period, around 1439. This complex had originally been commissioned from Donatello, but was later entrusted to Luca, for reasons which we do not know. Only two panels from the altars are still in existence; they are kept in the National Museum of the Bargello. These two unfinished marble bas-reliefs represent the *Deliverance of St. Peter* and the *Crucifixion of St. Peter*. The first panel adheres to the traditional iconography of the scene, and only the rounded forms of the angel reveal the typical qualities of Luca's art, almost in anticipation of the *Tabernacle of Peretola*. The panel with the *Crucifixion*, on the other hand, seems modelled after a fresco by Masaccio. Uncertainty about the attribution of these panels arises both from the heaviness of the architectural portions and from the narrative elements which recall, although

7

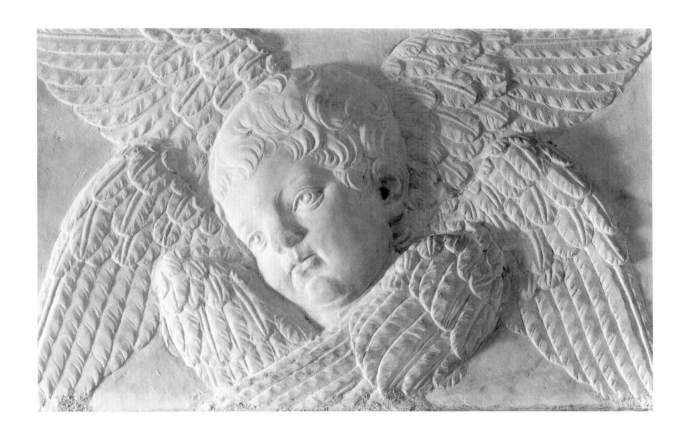

LUCA DELLA ROBBIA
(1454-1457; marble)
Tomb of
Bishop Federighi, detail
Church of Santa Trinita
Florence

in an uncertain way, the styles of Ghiberti and Della Quercia as well as Masaccio.

After this critical period, Luca's art went through an extremely inventive phase, during which he gave up working in marble and began his vast production of works in enameled terracotta: "For, considering that clay was easy to work with and that all he needed was to find a way of preserving for a long time the works made with it, he eventually dreamed up a way of defending them from the effects of time. After having experimented with many things, he found that covering them with a layer of glazing made of tin, antimony and other minerals and mixtures, cooked in an especially designed oven, he obtained this result and made sculptures in clay practically eternal" (Vasari). With this new material and technique, Luca and the other artists in his workshop, Andrea and Giovanni (to whom Vasari, perhaps arbitrarily, attributes the invention), discovered a medium which was ideally suited to express that Olympian, serene calm which characterized their vision of the world.

Actually, enameled terracotta (that is, oven-baked twice) was not invented by Luca. Long before his time, in the East, plates and vases had been produced using this technique and surely he had seen some of them, or heard of them. Nonetheless, it was Luca who learned how to exploit this invention; he applied it to large compositions, usually bas-reliefs, which he baked only once, and he successfully created works of outstanding quality.

page 6

Among the earliest works in this medium was the *Tabernacle of the Sacrament*, in marble, bronze and enameled terracotta, now in the church of Santa Maria at Peretola. This work was begun in 1441 and the bronze parts were completed with the help of Antonio di Cristofano in 1443. It was originally created for the choir of the church of Santa Maria Novella in Florence. In conformity with the taste of the time, Luca obtained vivid effects of color, flickering and darting from the white of the marble to the blue of the seraphim in the corners, to the red of the central cherub, to the polychrome tints of the garland. All this creates an effect of surprising luminosity.

page 4

Another important project was the decoration of the Pazzi Chapel, for which Luca made twelve terracotta roundels with white figures of Apostles set against a blue background. These roundels certainly play a primary role in giving movement to Brunelleschi's architecture. When looked at closely, these figures seem to be profoundly immersed in thought.

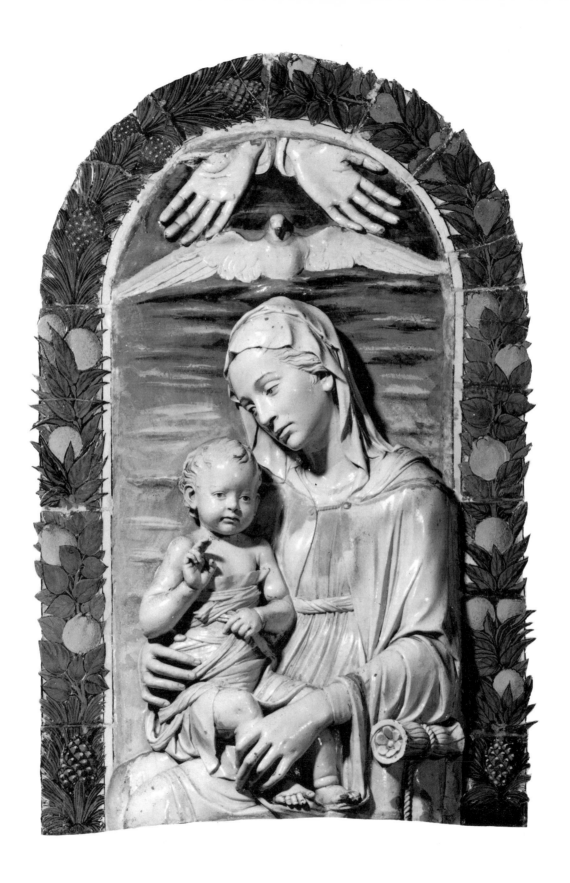

10

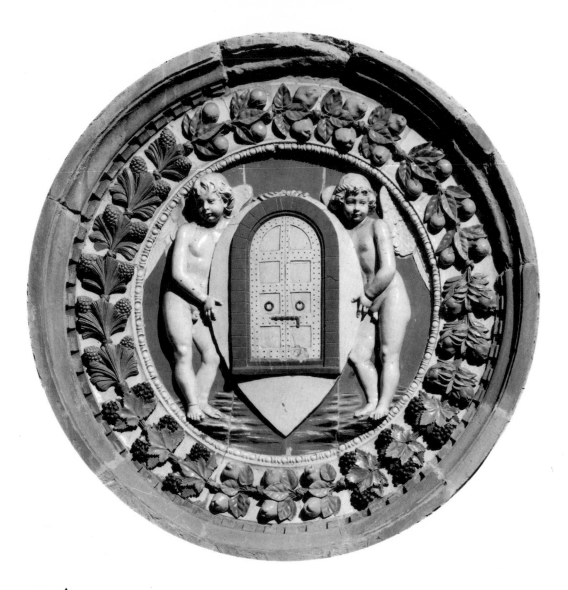

▲
LUCA DELLA ROBBIA
(1450-1460;
enameled terracotta)
Emblem of
the Guild of Silkworkers
Church of Orsanmichele
Florence

◄
LUCA DELLA ROBBIA (?)
(after 1450; 4'1" × 2'7";
enameled terracotta)
Madonna and Child
Church of San Gaetano
Florence

11

page 37

A new artistic impetus, more closely related to Donatello's work, can be noticed both in the lunette of the *Resurrection* (executed for the door of the North Sacristy between 1442 and 1445) and in the lunette of the *Ascension* (for the door of the South Sacristy between 1446 and 1451), both in the Cathedral of Florence. These lunettes are also white on a blue background, a scheme which Luca was to employ frequently and which was well-suited to creating figures of modulated sculptural effect. The *Resurrection* and the *Ascension* reveal the full extent of the elegance of form which Luca had attained in the modelling of "his" material; terracotta was, in fact, much more suited than marble for creating the characteristic roundness of his figures.

The many representations of the Madonna and Child, now scattered in museums and collections throughout the world, show the full extent of the delicacy of Luca's art. The earlier ones are the *Madonna of the Apple*, the brightly colored *Madonna of the Rosegarden*, the calm and beautiful *Madonna of Santa Maria Nuova*, the pensive *Madonna of the Cappuccini Tondo*, all in the National Museum of the Bargello. We must also mention the rather Gothic and certainly late *Madonna of San Pierino*, today in the Palazzo di Parte Guelfa in Florence, the very elegant *Madonna of the Innocents*, the bright and colorful *Madonna* placed in the center of the emblem of the Guild of Doctors and Apothecaries on the wall of the church of Orsanmichele in Florence, the *Altman Madonna* in the Metropolitan Museum of Art in New York, the *Frescobaldi Madonna* in the Staatliche Museen in Berlin, the *Genoa Madonna* in the Kunsthistorisches Museum in Vienna. These works all have in common a simplicity of form which reflects an inner simplicity of feelings. This has been quite aptly called "classical naturalism" and it is the very same emotion that only Raphael was to understand and convey in his Madonnas of the Florentine period. The particular feature of these Madonnas is the blending and the play of light and subtle coloring on the smooth surfaces which softens the sculptural effect, creating a soothing image of sweetness; the decorative and compositional elements become more and more simple, concise and reduced to the essential.

pages 38, 39

page 43
page 48

Undoubtedly Luca's fame and popularity is due primarily to his work in enameled terracotta, but we must not underestimate the quality and beauty of the bronze reliefs on the door to the North Sacristy in the Cathedral of Florence, which were carried out together with Michelozzo and Maso di Bartolomeo. They are very reminiscent of Donatello's reliefs for the door to the Old Sacristy in the church of San Lo-

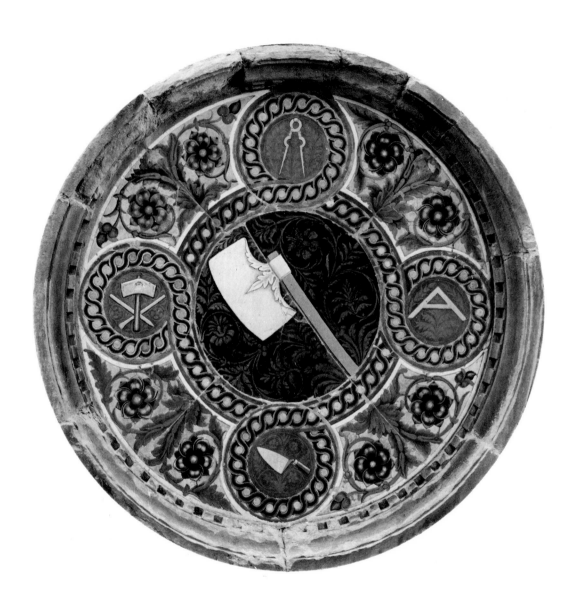

LUCA DELLA ROBBIA
(ca. 1466; tesserae of
enameled terracotta)
Emblem of the Guild of
Stonemasons and
Woodworkers
Church of Orsanmichele
Florence

13

renzo, and they are proof of Luca's technical ability even in this medium. The English art-historian Pope-Hennessy maintains that: "Whereas in Donatello's doors the function of the frame is to link each scene to the next, in Luca's the moulding shuts in the scenes, and each relief is contructed with its familiar system of verticals and horizontals as a unit independent of the rest." The most graceful and lyrical parts of this work are not the representations of the *Doctors of the Church* placed in the frames, on the whole rather monotonous and not even certainly attributable to Luca, but the delicately sculpted little heads at the corners of each of the ten panels.

page 41

page 40

Luca's most poetic creation, after the exquisite terracotta Madonnas, are the two *Angels with Candlesticks* (white enameled terracotta), carried out around the middle of the century and now housed in the South Sacristy in the Cathedral of Florence. These had been originally commissioned for the Chapel of the Sacrament in the same church. With these two figures, executed with extreme simplicity, Luca attains a very intimate and subdued spirituality. The young Michelangelo was obviously influenced by these figures when he sculpted his angels with candlesticks for the tomb of St. Dominic in Bologna. Today the two angels have lost their wings: originally carved in wood, these decayed and were eventually entirely lost, but the sculptures have probably gained something in grace and immediacy. This same "Renaissance composure" can also be noticed in the lunette above the door of the church of San Domenico in Urbino, to be dated around 1449-1450. The central group of the *Madonna and Child* holds a scroll with the inscription, repeated in many of Luca's works, "*Ego sum lux mundi*" (I am the light of the world). Next to them stand four saints: Dominic, Thomas Aquinas, Albert the Great and Peter the Martyr.

Luca's numerous sculptures in full relief, in which grace and sweetness are the dominant emotions, are the opposite of Donatello's, but still in a naturalistic vein. In the works carried out between 1445 and 1455 Luca found the way to express that sweetness of emotions which, although not yet completely visible in the *Cantoria*, from this stage onwards became an integral part of his art.

pages 8, 44-45

From 1454 to 1457 he was busy working at the *Tomb of Bishop Benozzo Federighi* for the church of San Pancrazio in Florence. When this church was deconsecrated in 1809, the tomb was moved to the church of San Francesco di Paola at the foot of the hill of Bellosguardo, on the outskirts of the city. In 1896 it was transferred again, this time to the church of Santa Trinita, where it still is today. We can say, as

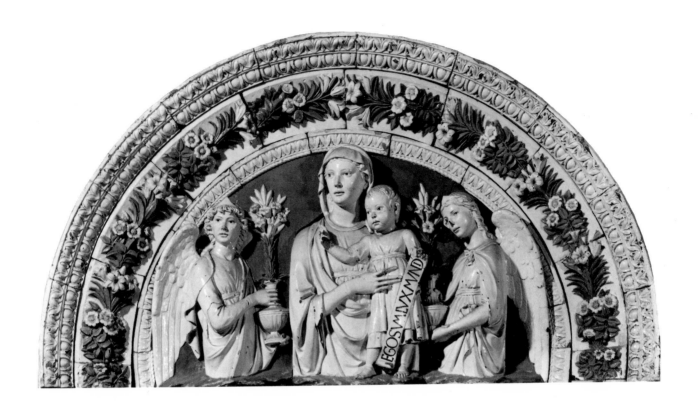

LUCA DELLA ROBBIA
(1471-1482; 5'2" × 7'3";
enameled terracotta)
Madonna of Via dell'Agnolo
National Museum (Bargello)
Florence

A.M. Petrioli points out, that this work, which is a typical example of a wall-tomb, "entirely based on a rhythm of regular scansions which harmonize with each other with the same precision as a mathematical theorem, supplies us with an excellent example of the principles of measure and balance of the Renaissance."

It is quite probable, as has already been suggested, that the monument originally had a much more complete architectural structure. But even in its present reduced form it is still an admirable and fascinating blend of marble and enameled terracotta, which here has the function of a decorative framework, done in "tesserae" with recurrent motifs, not in relief but with very bright and charming color patterns. These are representations of flowers and plants and Del Bravo has suggested that they may have been influenced by Iranian-Ottoman art. Such a decoration for a stern and rigid piece of marble sculpture, although delicately carved, creates a wonderfully moving effect.

pages 46-47

In the decade between 1460 and 1470 Luca carried out the multi-colored enameled terracotta decoration for the ceiling of the Chapel of the Cardinal of Portugal, in the church of San Miniato al Monte just outside Florence. In the five roundels he placed the *Holy Spirit*, in the center, surrounded by *Fortitude, Temperance, Prudence* and *Justice*. Once again, the enameled terracotta blends harmoniously with the architecture, the painting and the marble decoration of the whole. In 1466 Luca finished the emblems of the Guilds for Orsanmichele: for

page 13

the Guild of Stonemasons and Woodworkers (above the Tabernacle of the Four Crowned Saints by Nanni di Banco), for the Guild of Doctors

page 48

and Apothecaries and for the Guild of Merchants. Lastly, many years later, Luca decorated the two little temples by Michelozzo in the church of Santa Maria in Impruneta near Florence. The most successful part

page 49

of this work is the *Crucifixion*, with St. John the Baptist and an unidentified saint with a bishop's mitre. As in the tomb of Benozzo Federighi, the brightly colored enameled terracotta is used as a contrasting element and as a pictorial addition to the architectural complex.

The works at Impruneta are the last of Luca's documented works; the artist, who died on 20 February 1492, left the secret of his technique, so successfully developed in his workshop, to his nephew Andrea and to the latter's son Giovanni.

It is to Andrea, the son of his brother Marco, that Luca leaves the direction of the Florentine workshop "of the Della Robbia family" in 1470. Among all Luca's followers, Andrea was his closest collaborator and the one who best learnt how to interpret the master's feelings, to

16

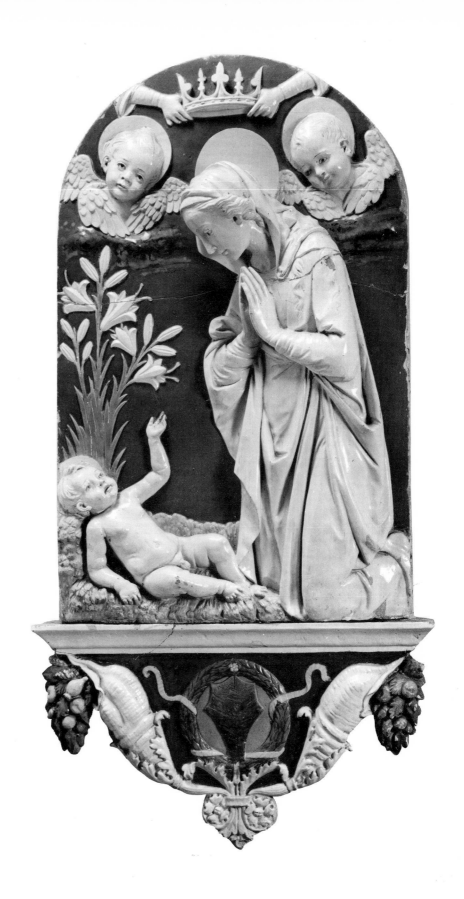

ANDREA DELLA ROBBIA
(1475-1480;
enameled terracotta)
Adoration
National Museum (Bargello)
Florence

the extent that often critics have not been completely sure whether to attribute a work to Luca or to Andrea. Born in Florence in 1435, Andrea shows throughout his long and prolific career, at times of purely commercial quality, a much more accentuated use of color than Luca. Among Andrea's first artistic works are the group of "putti" in the roundels between the arcades of the façade of the Hospital of the Innocents (or Foundlings); their resemblance to the decoration of the Pazzi Chapel and of the Chapel of the Cardinal of Portugal is evidence of his unceasing wish to emulate the ways of the master. They were probably carried out between 1463 and 1466, as Marquand suggests, and, therefore, probably under the guidance of Luca. This group is one of the most famous and popular achievements of the Della Robbia workshop. The white "putti" on blue background are portrayed, in their pose and expression, with great realism and simplicity. Also for the Hospital of the Innocents, Andrea created one of his best works, of exquisite grace: the *Annunciation*. The top part of the lunette is decorated with heads of cherubim, treated in the most varied ways. God the Father, as he appears to the group of the Virgin and the announcing angel, is supported by more cherubim. The center is marked by a flowering lily in a vase: the figures are white against a blue background. Since the influence of Leonardo da Vinci's *Annunciation* in the Uffizi is so obvious in this lunette, we can date it immediately after the painting (around 1470).

In the monastery of La Verna, near Arezzo, there are some works of Andrea's mentioned by Vasari. The earliest of these seems to be another *Annunciation*, simpler and decorated with more stylized motifs than the one in Florence. Without doubt, already in these two works we can see the change of taste from Luca's sombre ways. Those round and full forms, explicitly classical and geometrical like the works of Piero della Francesca, foreshadowing the style of Raphael, have completely disappeared from Andrea's work. Andrea, closer to Verrocchio and Leonardo, often complicates his images with sometimes useless details, and overloads them with bright colors. This is the case in this *Annunciation*, where the white-blue color relationship is interrupted in the background by very fine lines of clouds, in the attempt to provide spatial depth.

Andrea's free-standing sculpture of the *Visitation*, in white enameled terracotta, dates from the central period of his activity. It was done for a niche in the church of San Giovanni Fuorcivitas in Pistoia. This work still contains that extraordinary sense of purity and intensity of

page 50

page 51

page 51

▶
ANDREA DELLA ROBBIA
(ca. 1490; 20' high;
enameled terracotta)
Crucifixion
Monastery of La Verna
La Verna (Arezzo)

page 53

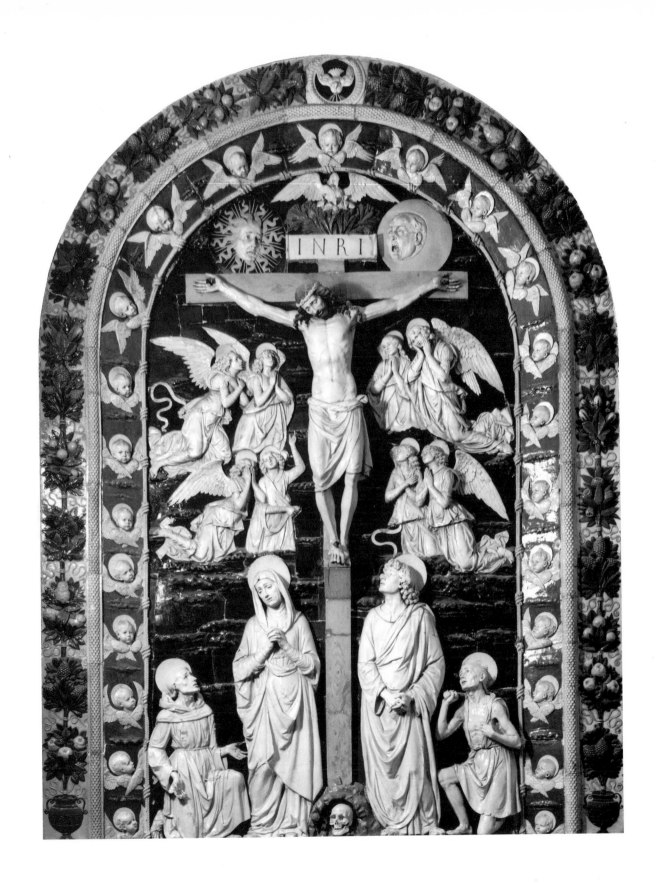

19

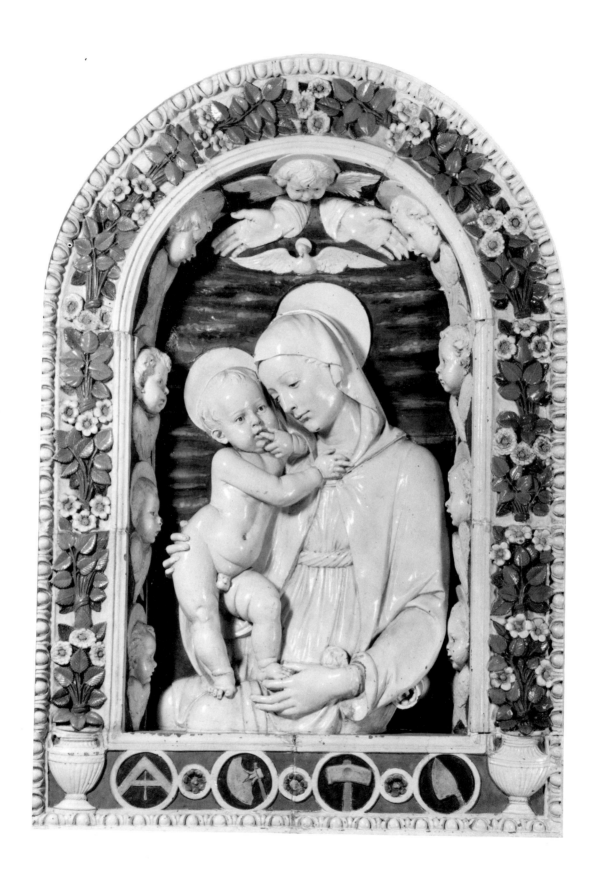

20

emotions which characterized Luca's best period, but the more accentuated and dramatized expression is a clear sign of Donatello's or Verrocchio's influence. The harder and more angular drapery folds, the realistically rugged hands and lined face of St. Elizabeth (which foreshadow the faces and hands in the later *Meeting Between St. Francis and St. Dominic*), and her dramatic gesture as she kneels before the Virgin, are all details that tell us quite clearly that this is the work of Andrea, and not of Luca, as some scholars have suggested.

page 52

For the loggia of the Hospital of St. Paul in Piazza Santa Maria Novella in Florence, Andrea made a lunette, to be dated around 1493, with the *Meeting Between St. Francis and St. Dominic* and eleven medallions with portraits and saints a few years later (1498). The successful composition of the lunette, with the two saints embracing affectionately, and the richly colored terracotta, make this work very interesting. The faces and the hands of the two characters, very realistically carved, are not enameled: the untreated terracotta, in contrast to the brightly colored enameled robes, appears in its natural "burnt" color.

Andrea never really bothered to express the intimacy of sentiments, the reality of emotions, yet he succeeded in creating works of extraordinary delicacy and grace. These are not so much the works mentioned above as the many versions of the *Madonna and Child* (National Museum of the Bargello, Florence) and, even more so, the portraits of the boy, the lady and the unknown girl, all in the Bargello. The almost naughty expression of the boy, the discreet nobility of the lady and the slightly enigmatic thoughtfulness of the girl are communicated, in all their realism, by the carefully shaded white enamel of the heads, while the blue expanse, enlivened by greenish highlights, serves only as a background. The portrait of the girl is similar to the portraits of Desiderio da Settignano or Domenico Veneziano in the perfection of the profile; her hair, tied in bunches, contrasts vividly with the deep blue, from which emerges a typically Florentine face. Her long, slender neck, her hairdo, her jewels suggest that she is still very young, but already quite conscious of her femininity. Every time that Andrea recreates, even though with different basic characteristics, Luca's style and expression, he is capable of producing works of great artistic worth. But when his style becomes more complex, with more figures and a greater variety of colors, his work loses its artistic qualities and becomes pure artisanship. Pope-Hennessy points out: "A sensitive but facile sculptor, Andrea lacked Luca's seriousness. At his hands, Luca's nat-

pages 17, 20, 57

pages 55, 56, 58

◀
ANDREA DELLA ROBBIA
(after 1489; 4'4" × 3'1";
enameled terracotta)
Madonna of the Architects
National Museum (Bargello)
Florence

uralistic borders became conventionalized frames, Luca's Madonnas were weakened and sentimentalized, and Luca's spacious compositions were constricted and debased." This seems to be true, but only in part for the later period of Andrea's activity. See, for example, the *Tabernacle* in the Museum of Santa Croce or the *Crucifixion* of La Verna. The too heavily emphasized pictorial effects cause the sculptures to lose their clarity and the fluency of rhythm, and the works become simply an attempt at imitating painting. The great variety of color tonalities in the enamel are only evidence of technical ability. This is the main feature of almost the entire production of Giovanni, the son of Andrea, who took over the direction of the workshop in 1525. In a history of ceramics, Giovanni would certainly play a very important role, but in the world of sculpture he has no personality of his own. His main interest was constantly to copy from others and not only from the themes of his father's work, but also from all the sculptures, paintings and frescoes of his contemporaries, from Desiderio da Settignano to Antonio Rossellino, to Verrocchio, Botticelli, Ghirlandaio, Luca Signorelli, Perugino, Pinturicchio, Raphael, etc.

page 54
page 19

Yet among the enormous quantity of works produced by him, turned out in an almost industrialized fashion, there are a few pieces interesting at least for their decorative innovations. One such is the lavabo in the Sacristy of the church of Santa Maria Novella in Florence. It dates from 1497 and shows the influence of Andrea and of Desiderio da Settignano; the colorful landscape which serves as background to the marble basin is quite charming. Most of the enameled terracottas of the last of the Della Robbia family are compositions for very large altarpieces, with a great variety of colors; but almost always the overcrowding of the figures detracts from the expressive quality of the works. See, for example, the *Tabernacle* in the church of Santissimi Apostoli in Florence and the three works today in the Bargello, but originally commissioned for monasteries in Tuscany: the *Ascension*, from the monastery of San Vivaldo in Montaione, the *Resurrection*, dated 1510, from the monastery of Monteoliveto Maggiore, and the *Deposition*, very obviously influenced by the *Pietà* sculpted by Michelangelo around 1500 for St. Peter's in Rome. Giovanni used this last subject several other times: the most important is the lunette (1500-1510) for the church of San Salvatore a Monte in Florence, in which the figures are almost free-standing.

page 59

page 61

page 61

Among his groups of the *Madonna and Child*, we must point out the roundel of the *Madonna and Child with St. John* (National Museum

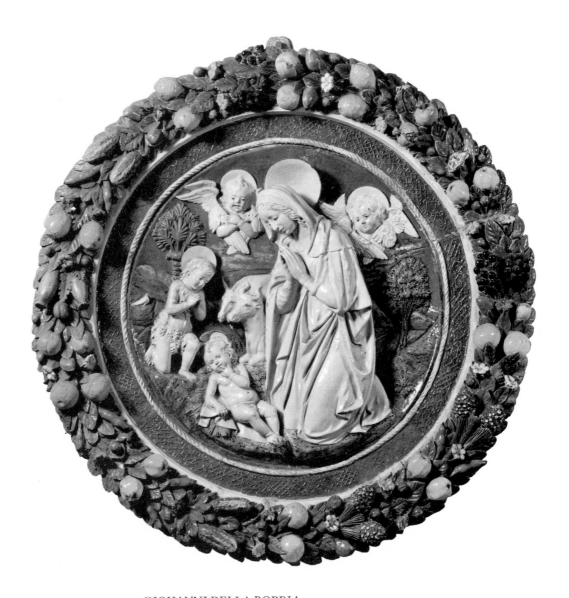

GIOVANNI DELLA ROBBIA
(enameled terracotta)
Adoration
National Museum (Bargello)
Florence

of the Bargello). Among his free-standing sculptures the most important is the bust of *St. Ursula*, originally in the convent of the same name. The *Medici-Bartolini Salimbeni Tondo*, with its extraordinarily brilliant colors, stands somewhere between majolica and sculpture. It is a combination of the emblems of the two families: the three feathers (red, white and green) and the three diamond-rings of the Medici interwoven with the yellow poppy seed-pods of the Bartolini Salimbeni.

page 62
page 63

But Giovanni's most important work is the decoration of the new portico of the Hospital "del Ceppo" in Pistoia, illustrating the Acts of Mercy and the Virtues. Designed by Giovanni, they were probably carried out in 1525 with the help of the sculptor Santi Buglioni. They show a strongly realistic inspiration and have been used many times as models for various works in terracotta of good workshop quality. From the linear purity expressed in many of Andrea's and Giovanni's works, the production of the workshop passes very soon to exclusively commercial work. Yet the Della Robbia workshop still produced a great number of terracotta roundels, portraits and tabernacles. Although the artistic quality of these works was a far cry from that of Luca's works, we must at least give their creators credit for technical skill. The blue and white of the Madonnas, the emerald green of the garlands of laurel leaves combined with the bright yellow of the lemons, have traditionally become the symbols not only of Florence, but of an entire artistic age.

page 64

BIBLIOGRAPHY

1568 Vasari G., *Le vite de' più eccellenti pittori, scultori ed architettori*, ed. Club del libro, vol. II, Milano 1962.
1902 Cruttwell M., *Luca and Andrea della Robbia and their Successors*, London-New York.
1908 Venturi A., *Storia dell'arte italiana, VI, la scultura del quattrocento*, Milano.
1914 Marquand A., *Luca della Robbia*, Princeton.
1919 Marquand A., *Robbia Heraldry*, Princeton.
1920 Marquand A., *Giovanni della Robbia*, Princeton.
1922 Marquand A., *Andrea della Robbia and his atelier*, Princeton.
1942 Salvini R., *Luca della Robbia*, Novara.
1954 Brunetti G., *Luca della Robbia*, Paris.
1958 Brunetti G., ad vocem « *Della Robbia* », in « Enciclopedia Universale dell'Arte », vol. IV.
1958 Pope-Hennessy J., *Italian Renaissance Sculpture*, London.
1960 Lisner M., *Luca della Robbia - Die Sängerkanzel*, Stuttgart.
1962 Brunetti G., *Note su Luca della Robbia*, in « Scritti di storia dell'arte in onore di Mario Salmi », II, Roma.
1965 Baldini U., *La Bottega dei Della Robbia*, in « Forma e Colore », 1, Firenze.
1966 Petrioli A. M., *Luca della Robbia*, in « I maestri della Scultura », 7, Milano.
1970 Avery C., *Florentine Renaissance Sculpture*, London.
1973 Del Bravo C., *L'Umanesimo di Luca Della Robbia*, in « Paragone », XXIV, 285.

© Copyright 1979 by SCALA, Istituto Fotografico Editoriale, Firenze
Photographs: SCALA
Printed in Italy by Coop. Officine Grafiche Firenze

LUCA DELLA ROBBIA
(1431-1439; ca. 11'6" × 18';
marble)
The Cantoria
Cathedral Museum
Florence

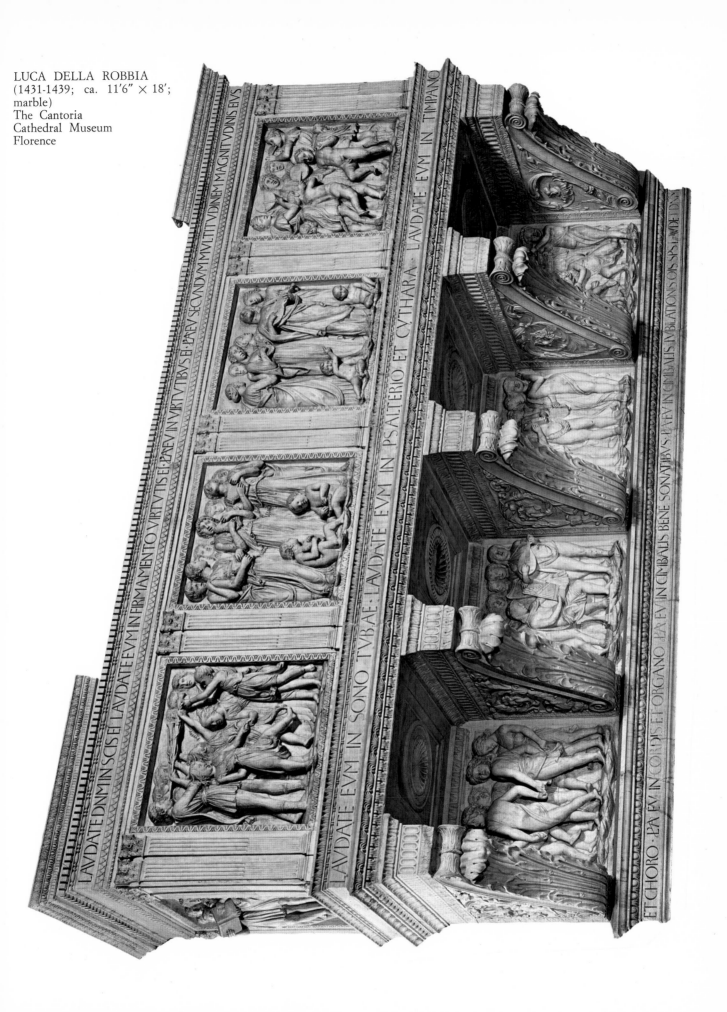

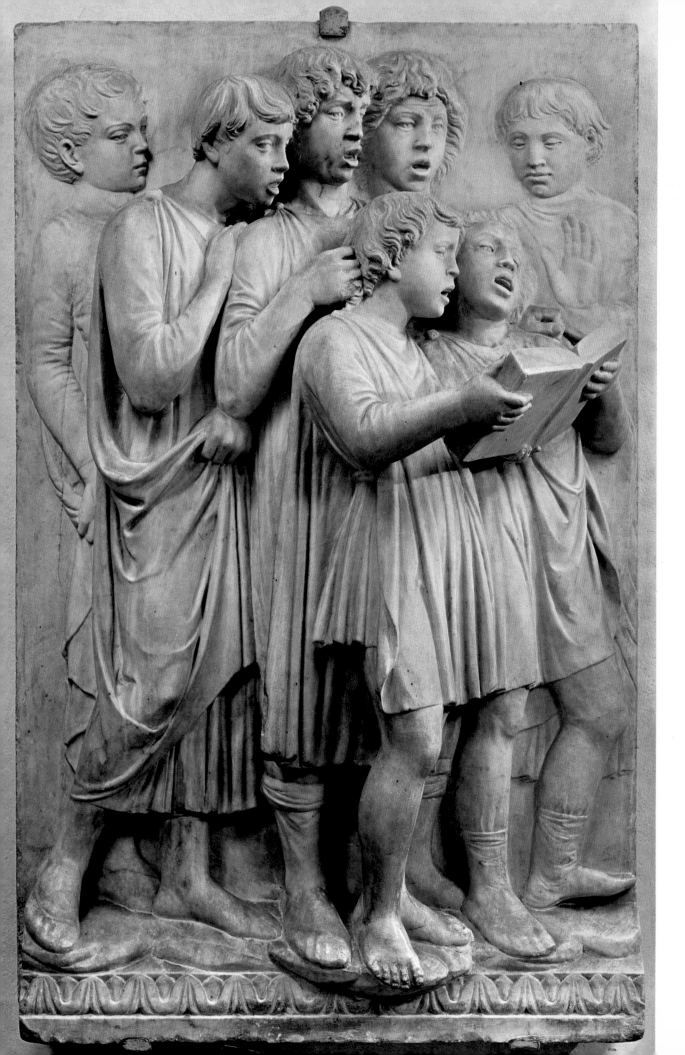

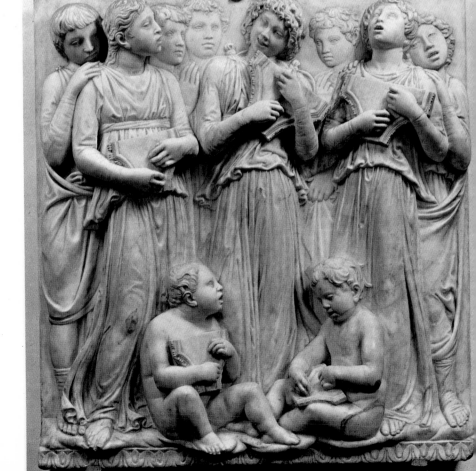

► LUCA DELLA ROBBIA
(1431-1439; 3'4" × 3'6";
marble)
Cantoria Panel
Cathedral Museum
Florence

► LUCA DELLA ROBBIA
(1431-1439; 3'4" × 3'6";
marble)
Cantoria Panel
Cathedral Museum
Florence

◄ LUCA DELLA ROBBIA
(1431-1439; 3'4" × 2'1";
marble)
Cantoria Panel
Cathedral Museum
Florence

27

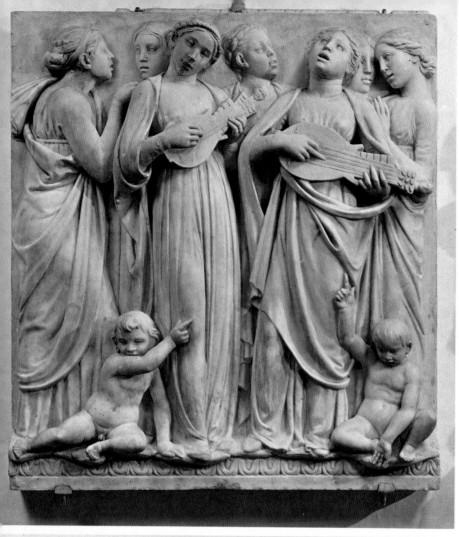

◀
LUCA DELLA ROBBIA
(1431-1439; 3'4" × 3'6";
marble)
Cantoria Panel
Cathedral Museum
Florence

◀
LUCA DELLA ROBBIA
(1431-1439; 3'4" × 3'6";
marble)
Cantoria Panel
Cathedral Museum
Florence

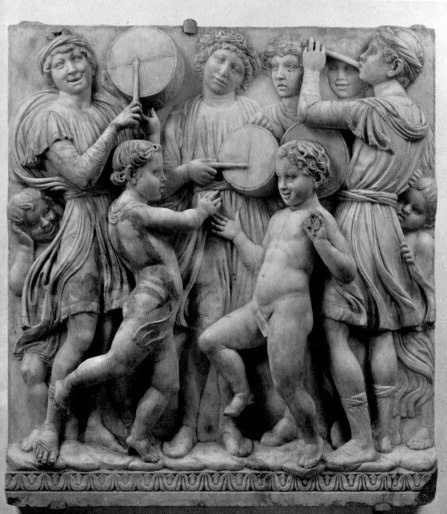

▶
LUCA DELLA ROBBIA
Cantoria Panel, detail
Cathedral Museum
Florence

28

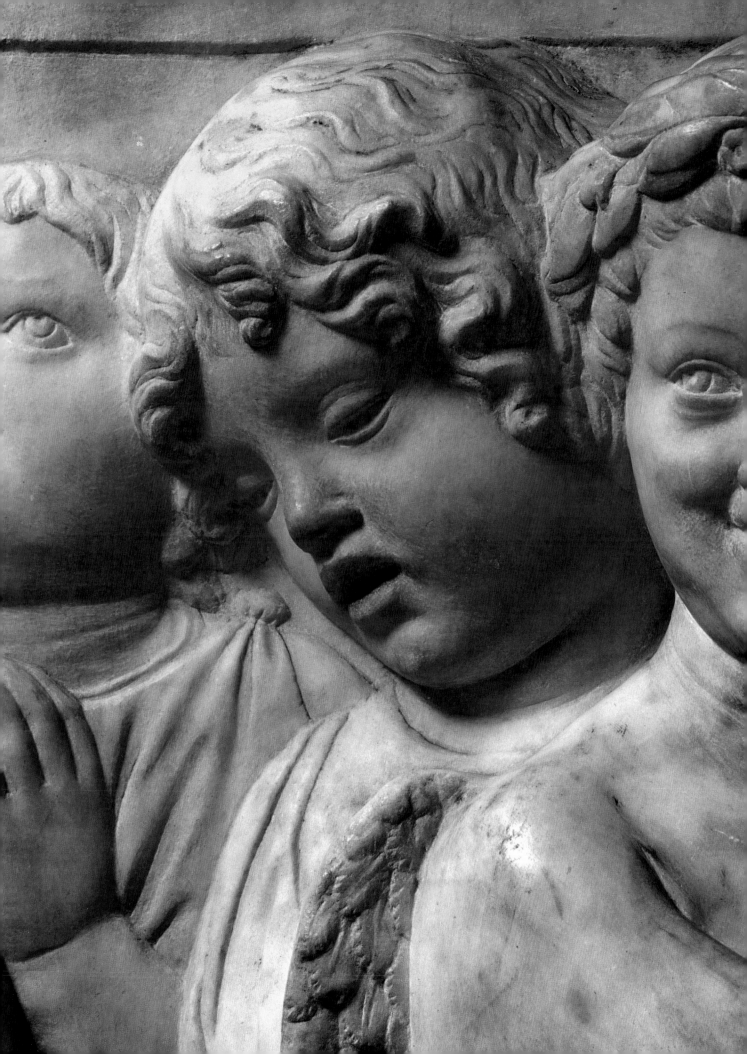

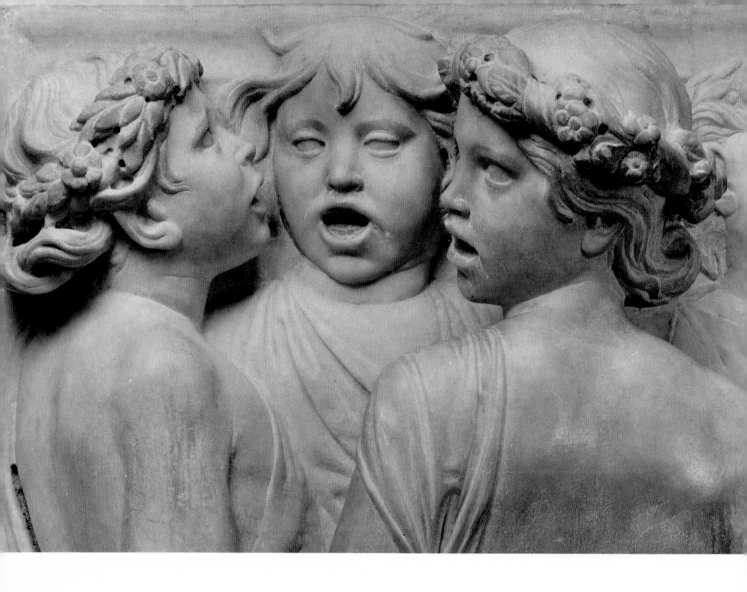

▲
LUCA DELLA ROBBIA
Cantoria Panel, detail
Cathedral Museum
Florence

▶
LUCA DELLA ROBBIA
Cantoria Panel, detail
Cathedral Museum
Florence

30

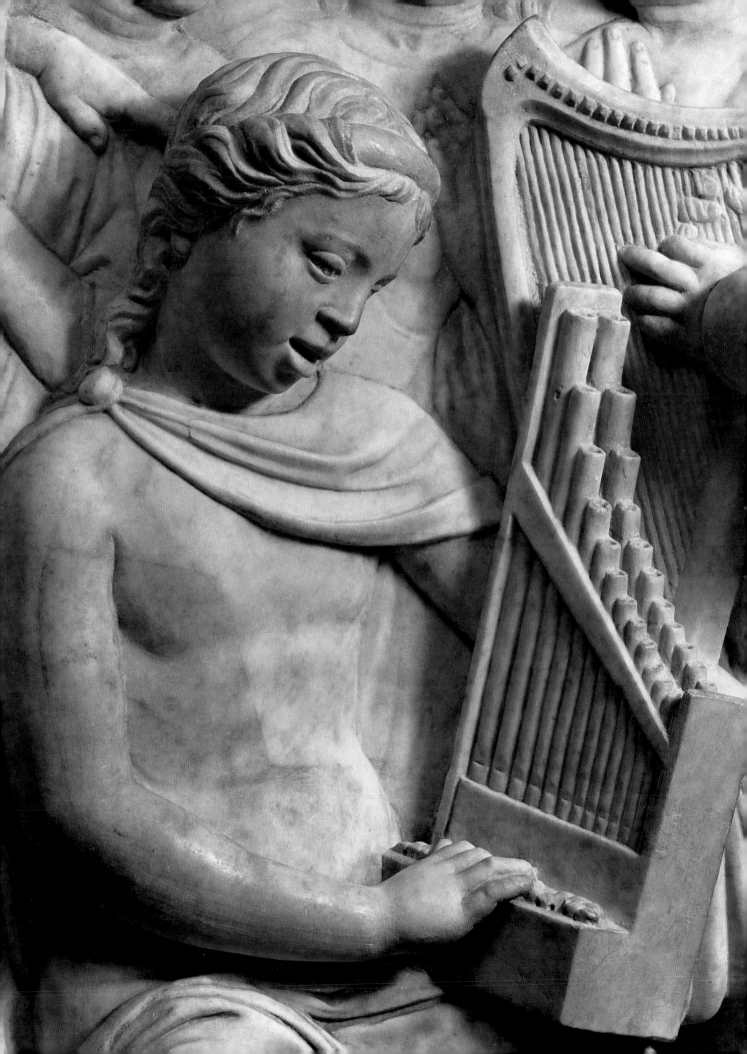

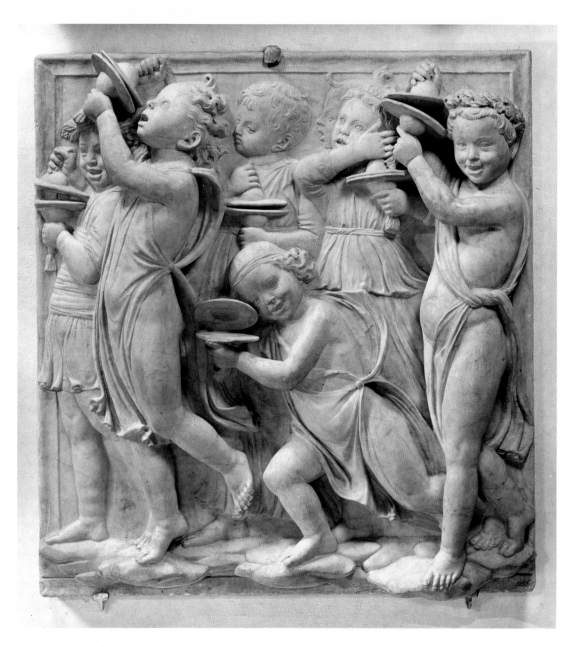

▲
LUCA DELLA ROBBIA
(1431-1439;  3'4" × 3'6";
marble)
Cantoria Panel
Cathedral Museum
Florence

▶
LUCA DELLA ROBBIA
(1431-1439;  3'4" × 2'1";
marble)
Cantoria Panel
Cathedral Museum
Florence

32

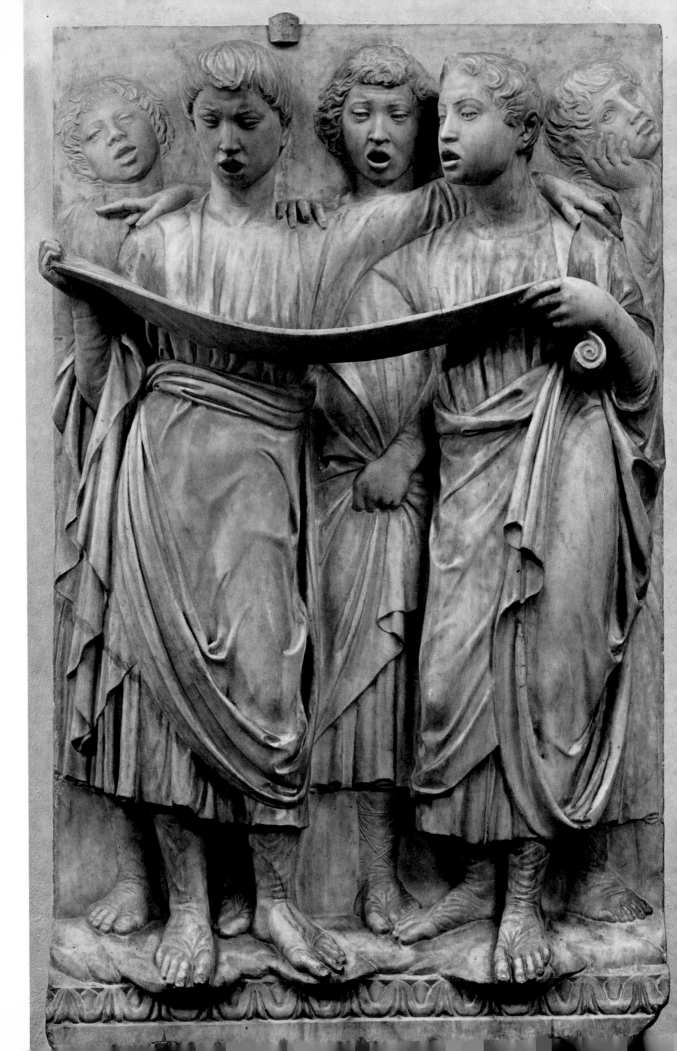

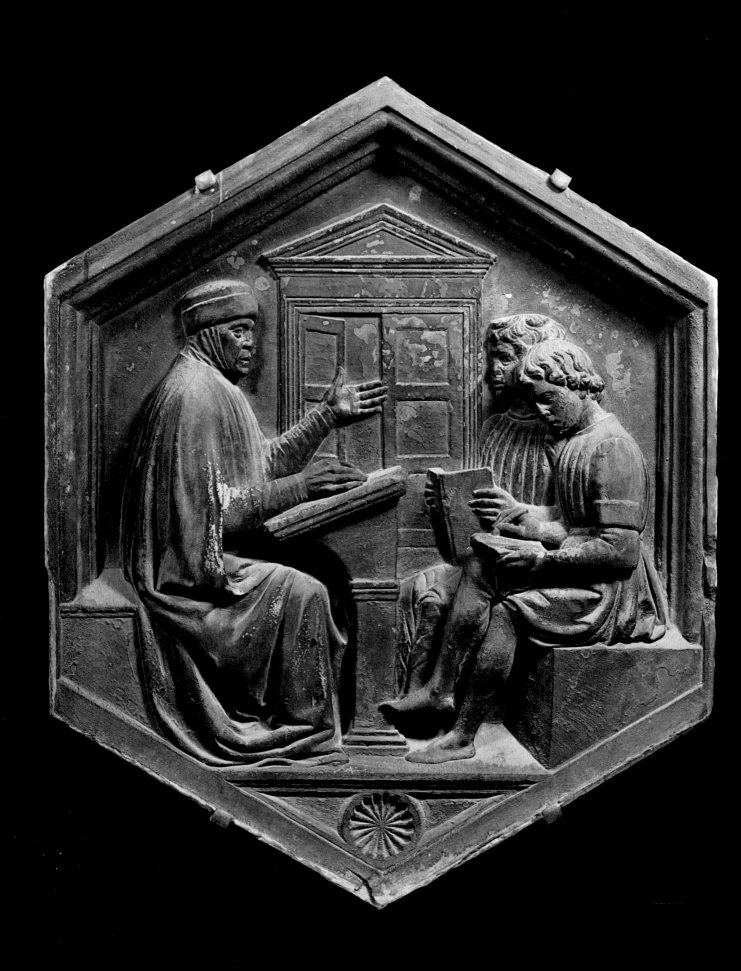

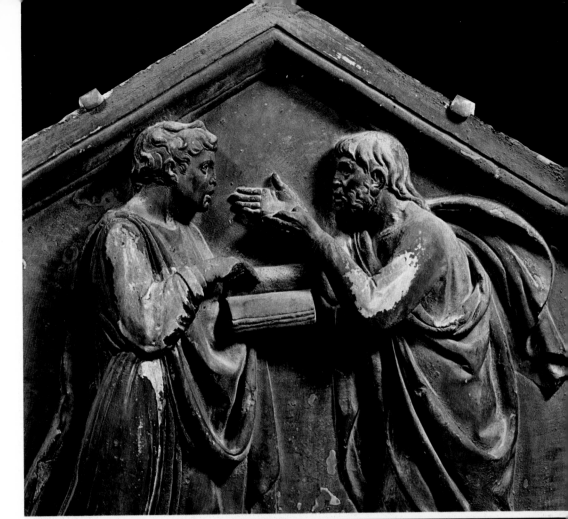

▶
LUCA DELLA ROBBIA
Philosophy, detail
Cathedral Museum
Florence

▶
LUCA DELLA ROBBIA
(1437-1439;  2'8" × 2'3";
marble)
Music, Orpheus
Cathedral Museum
Florence

◀
LUCA DELLA ROBBIA
(1437-1439;  2'8" × 2'3";
marble)
Grammar
Cathedral Museum
Florence

35

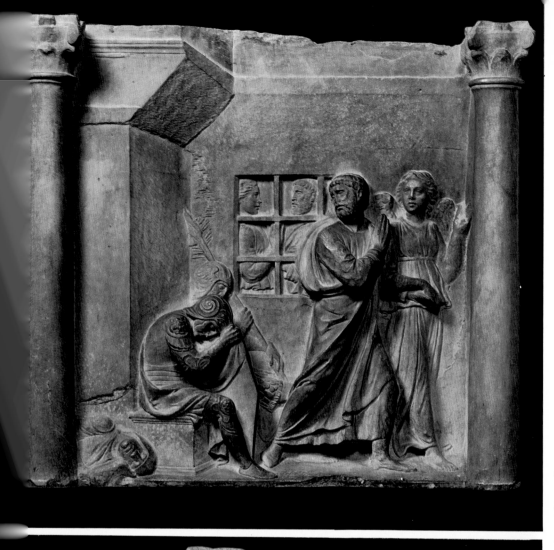

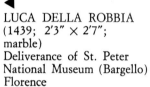

LUCA DELLA ROBBIA
(1442-1445; 6'7" × 8'6";
enameled terracotta)
Resurrection
Cathedral
Florence

◄
LUCA DELLA ROBBIA
(1439; 2'3" × 2'7";
marble)
Deliverance of St. Peter
National Museum (Bargello)
Florence

◄
LUCA DELLA ROBBIA
(1439; 2'3" × 2'7";
marble)
Crucifixion of St. Peter
National Museum (Bargello)
Florence

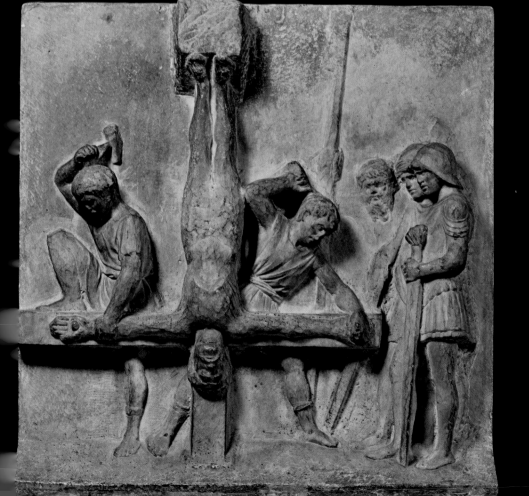

►
LUCA DELLA ROBBIA
(1446-1451; 6'7" × 8'6";
enameled terracotta)
Ascension
Cathedral
Florence

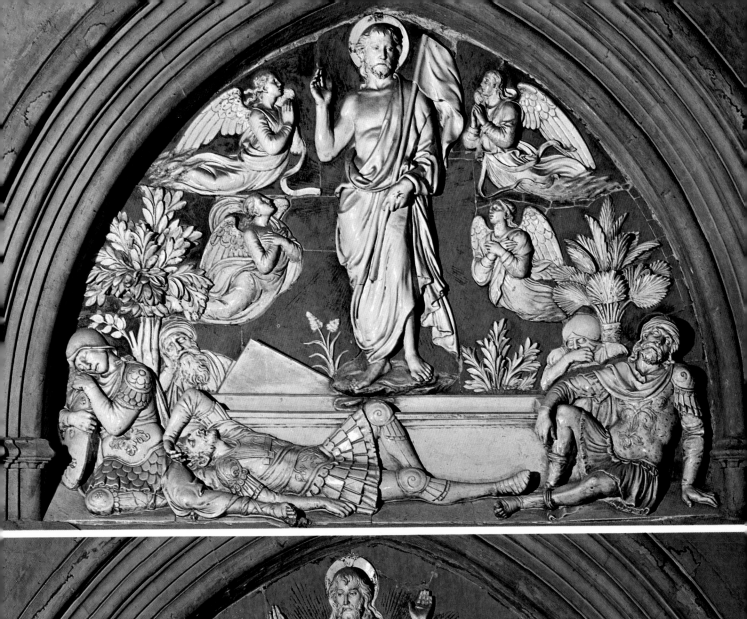
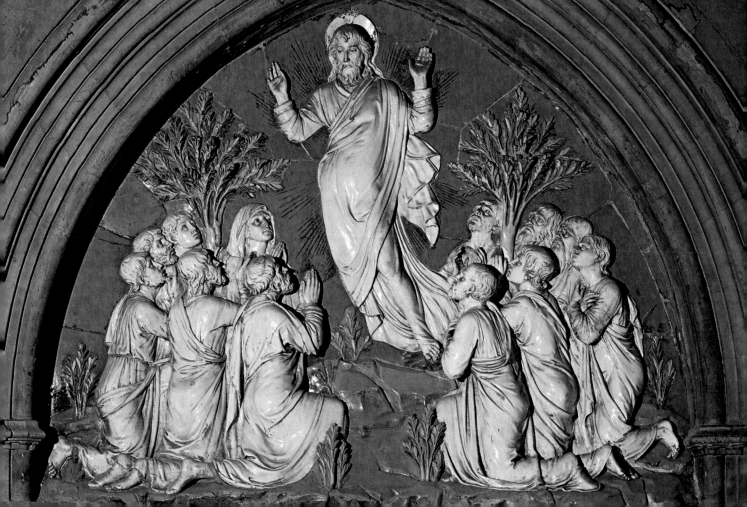

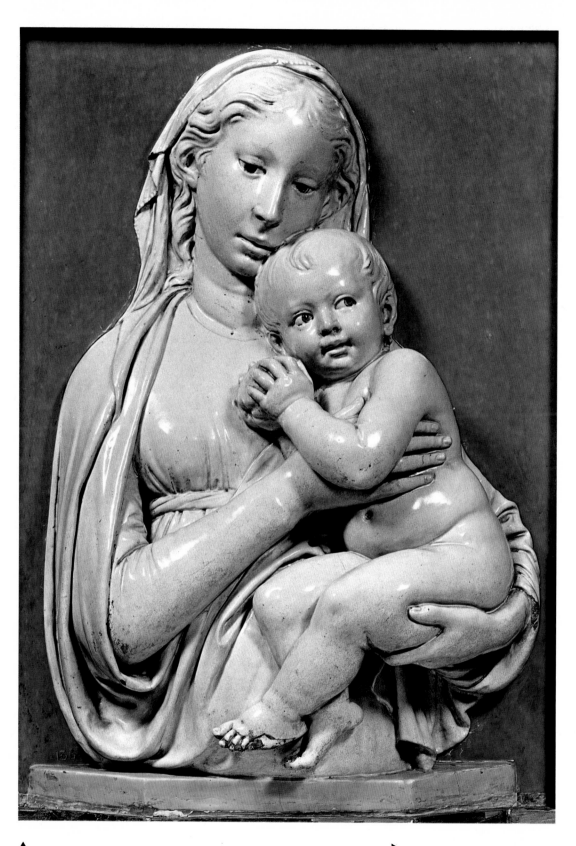

▲
LUCA DELLA ROBBIA
(ca. 1450; 2′3″ × 1′8″;
enameled terracotta)
Madonna of the Apple
National Museum (Bargello)
Florence

▶
LUCA DELLA ROBBIA
(1471-1482; 2′8″ × 2′1″;
enameled terracotta)
Madonna of the Rosegarden
National Museum (Bargello)
Florence

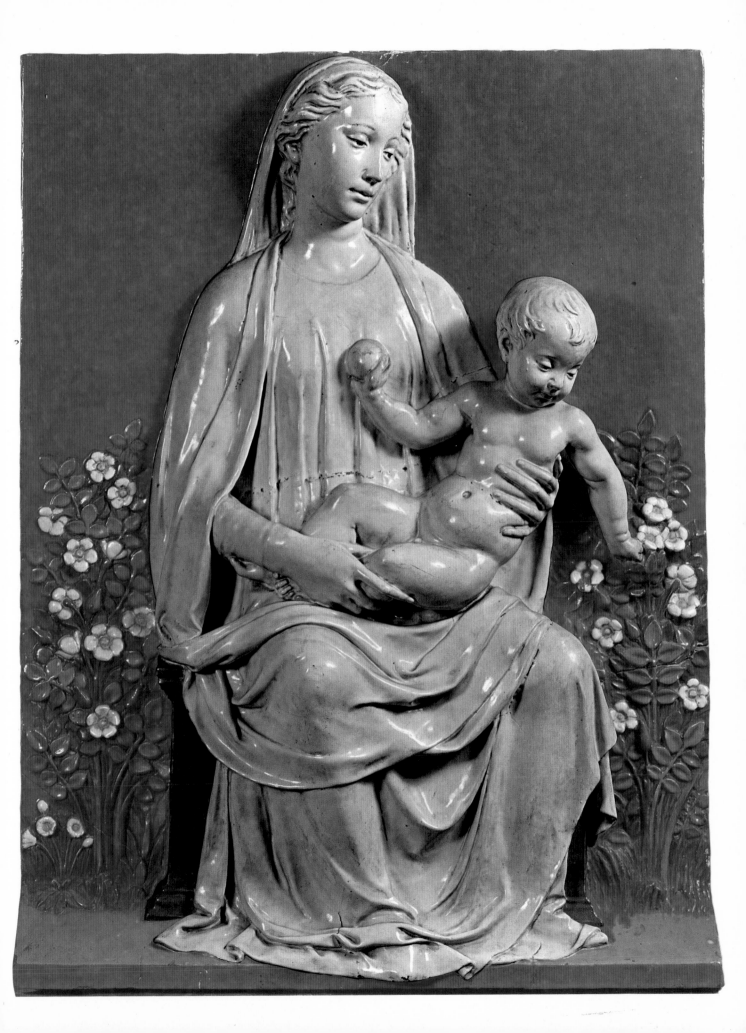

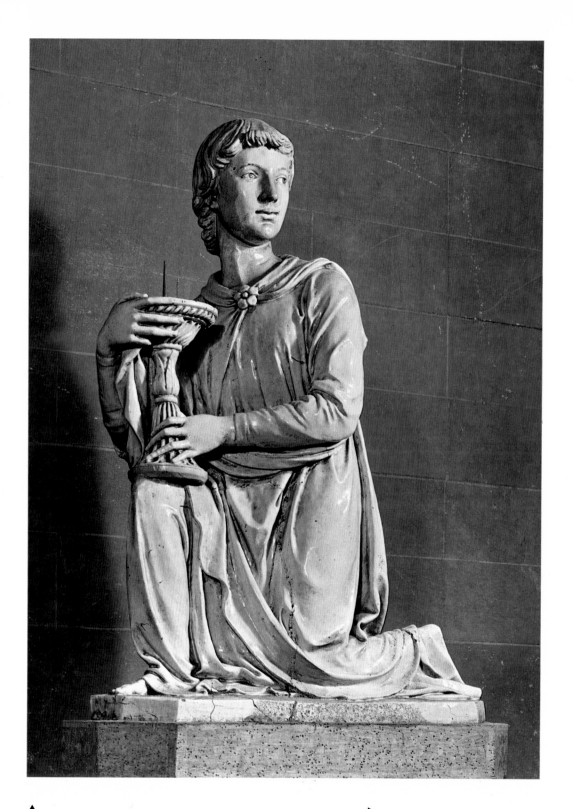

▲
LUCA DELLA ROBBIA
(1448-1451; 2'9" × 1'11";
enameled terracotta)
Angel with Candlestick
Cathedral
Florence

▶
LUCA DELLA ROBBIA
(1445-1452; 6" × 5";
bronze)
Head from bronze doors
Cathedral
Florence

40

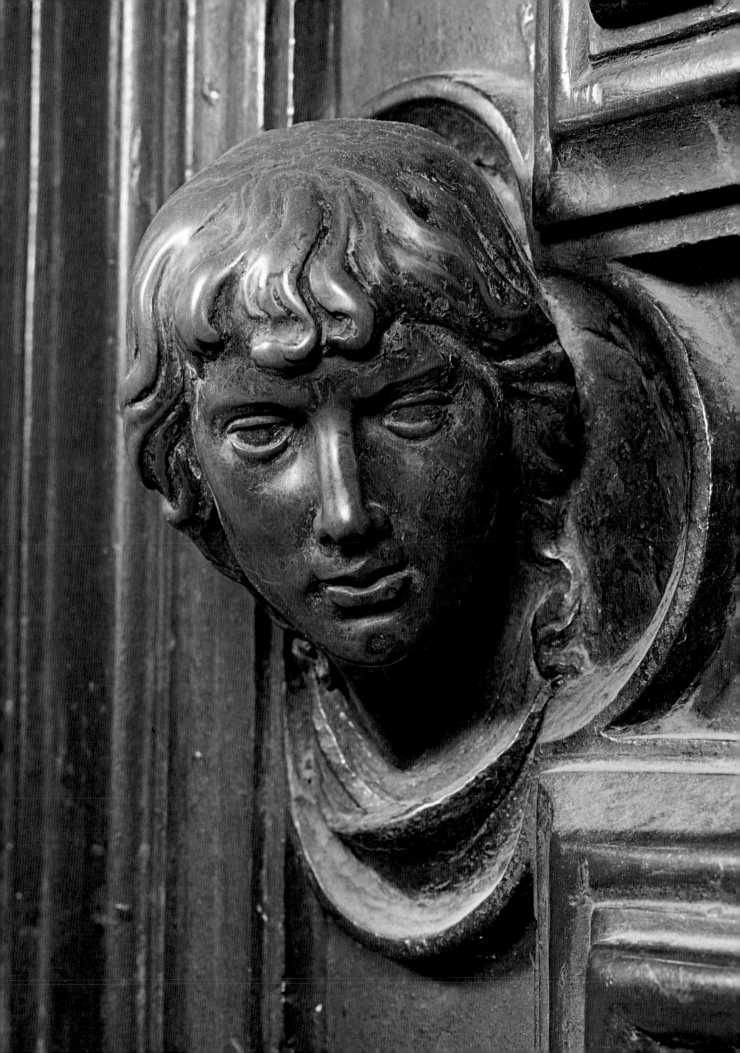

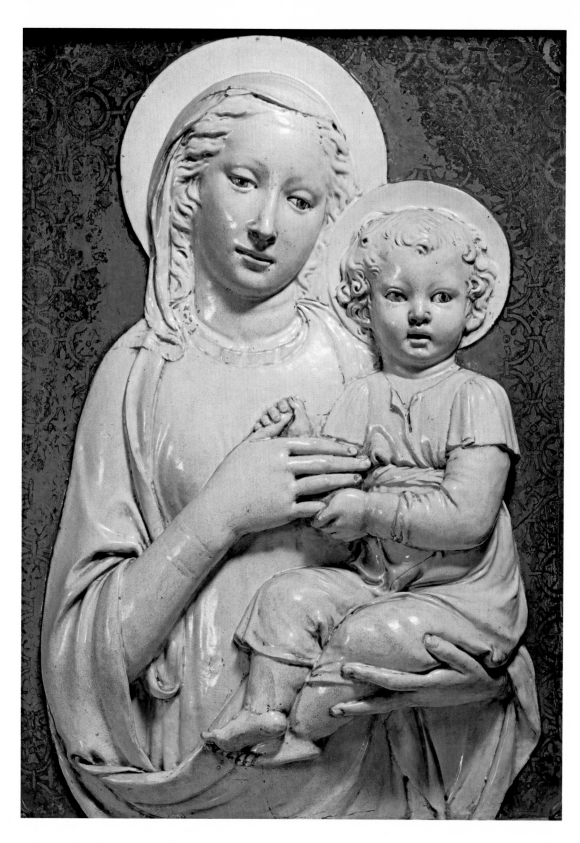

▲
LUCA DELLA ROBBIA
(after 1450; 2'1" × 1'7";
enameled terracotta)
Madonna of
Santa Maria Nuova
National Museum (Bargello)
Florence

▶
LUCA DELLA ROBBIA
(after 1450; 2'8" high;
enameled terracotta)
Madonna of the Innocents
Hospital of the Innocents
Florence

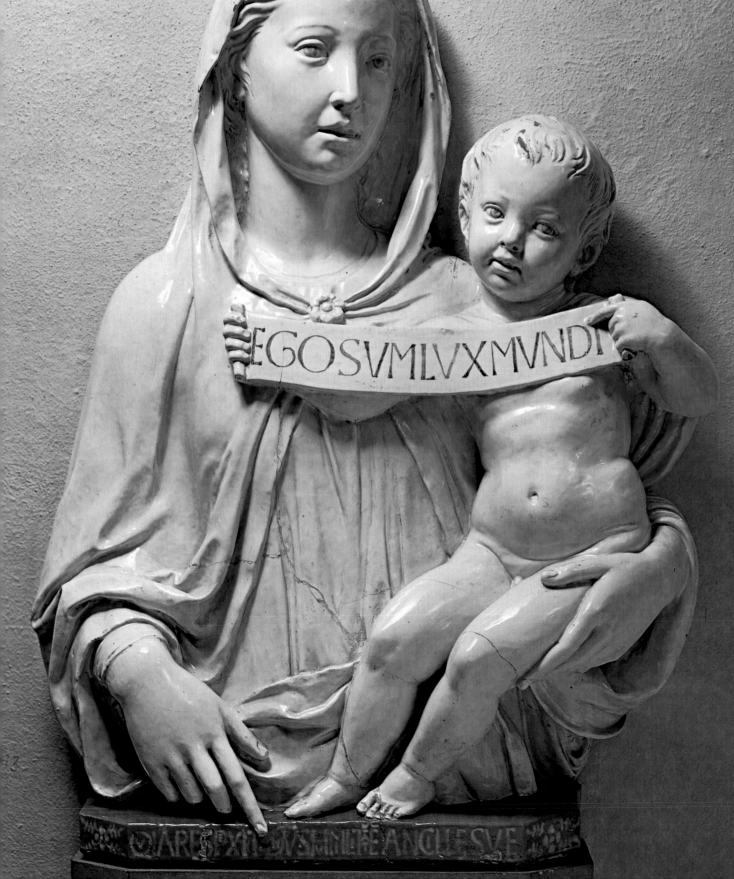

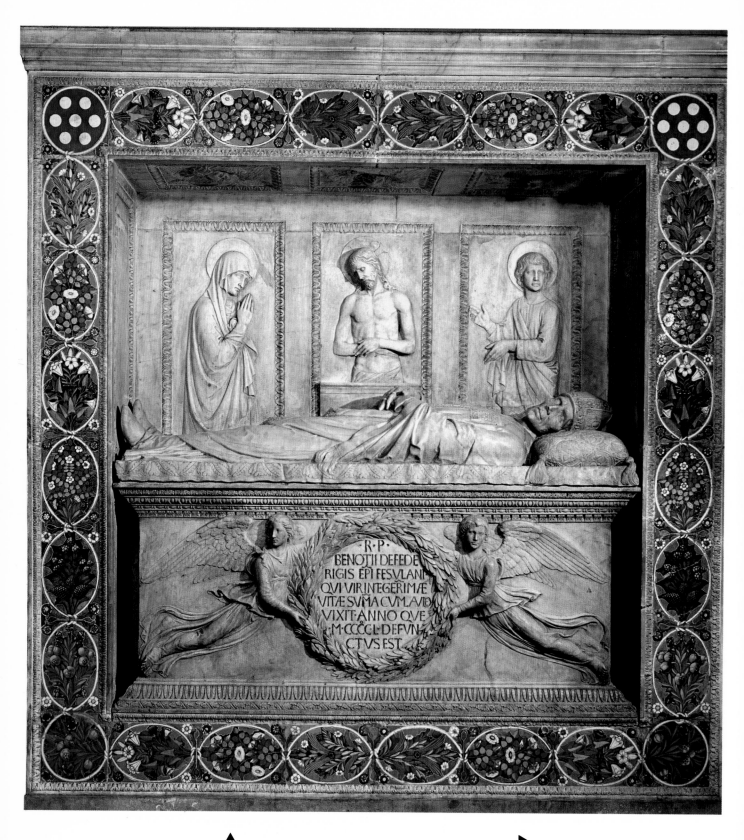

▲
LUCA DELLA ROBBIA
(1454-1457;  8'10" × 8';
marble)
Tomb of Bishop Federighi
Church of Santa Trinita
Florence

▶
LUCA DELLA ROBBIA
Tomb of Bishop Federighi,
detail of the framework
Church of Santa Trinita
Florence

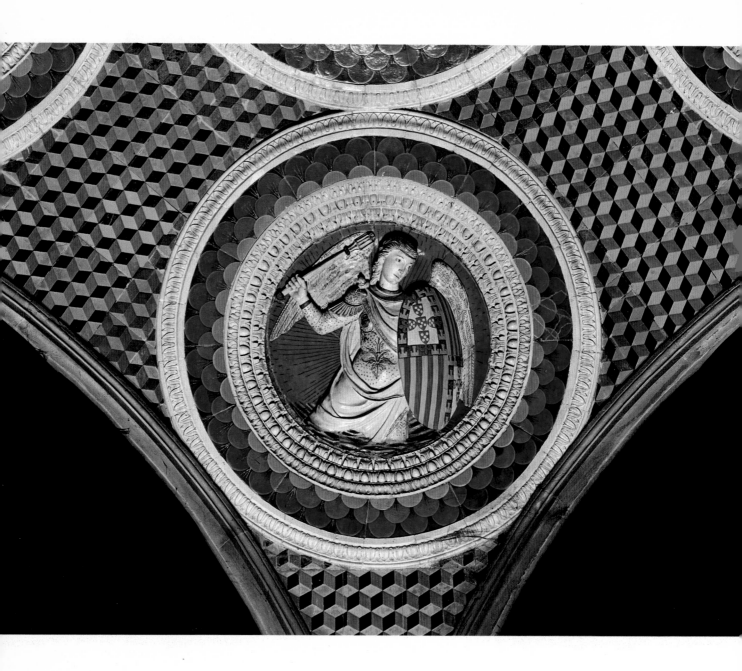

▲
LUCA DELLA ROBBIA
(1460-1470; 6'7" diam.;
enameled terracotta)
Fortitude
Chapel of the
Cardinal of Portugal
Church of San Miniato
Florence

▶
LUCA DELLA ROBBIA
(1460-1470;
enameled terracotta)
Decoration of the ceiling
of the Chapel of the
Cardinal of Portugal
Church of San Miniato
Florence

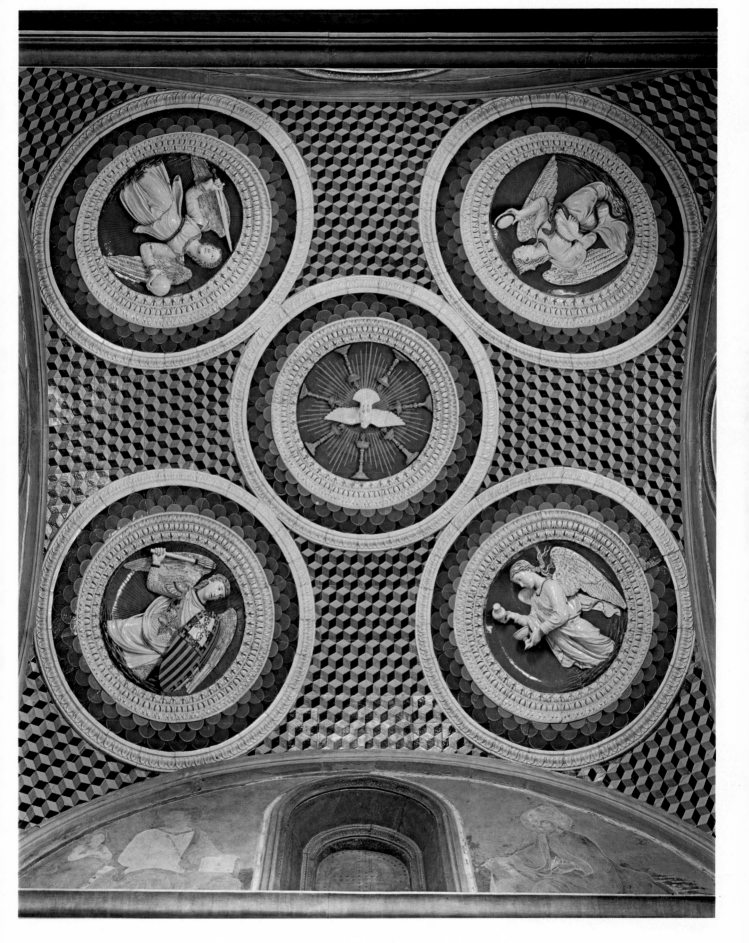

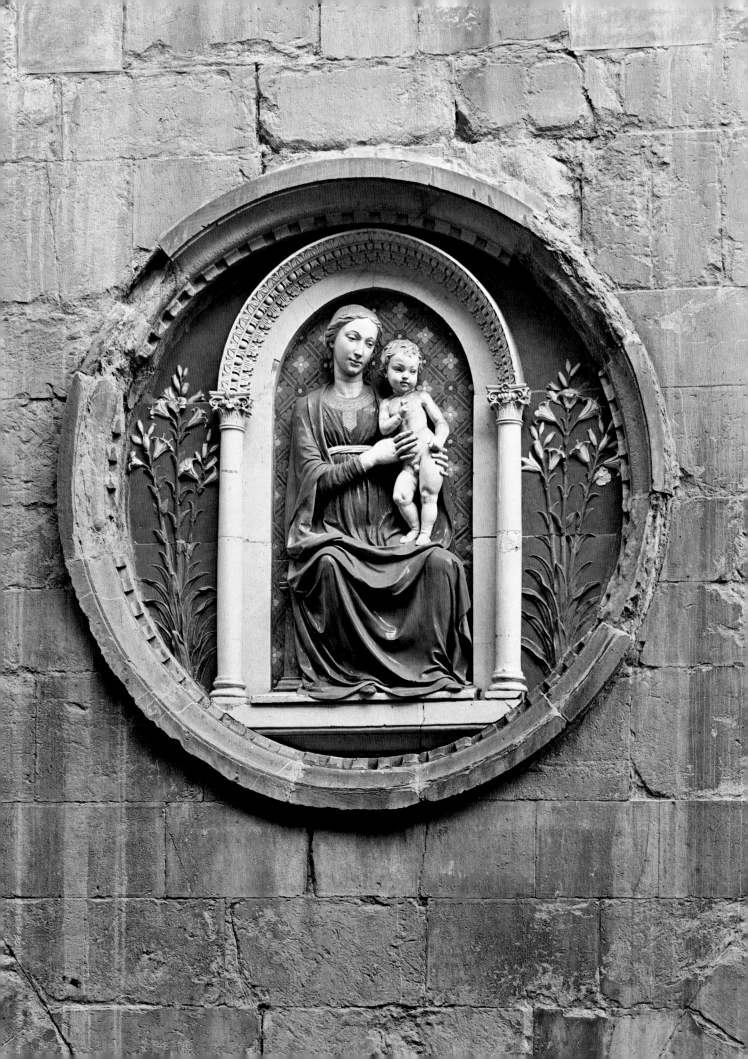

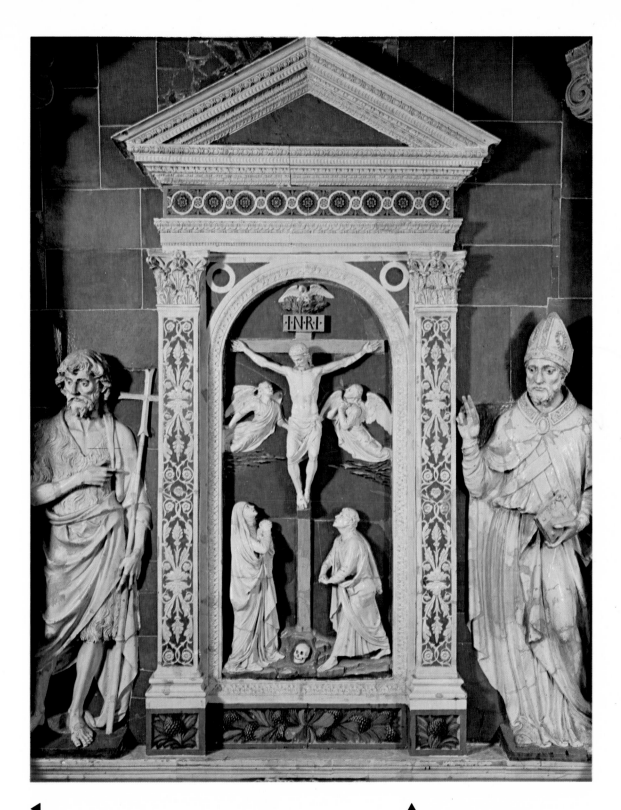

LUCA DELLA ROBBIA
(1466; 6'6" diam.;
enameled terracotta)
Emblem of the Guild of
Doctors and Apothecaries
Church of Orsanmichele
Florence

LUCA DELLA ROBBIA
(1470-1480; 4'11" × 2'2";
enameled terracotta)
Crucifixion
Church of Santa Maria
Impruneta (Florence)

49

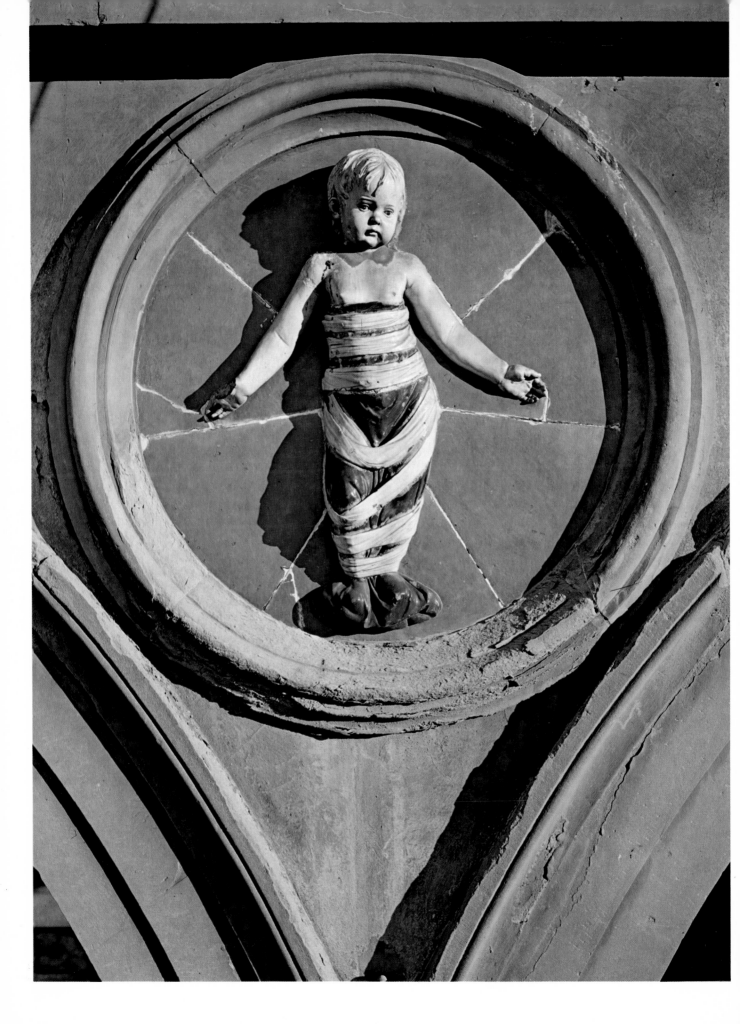

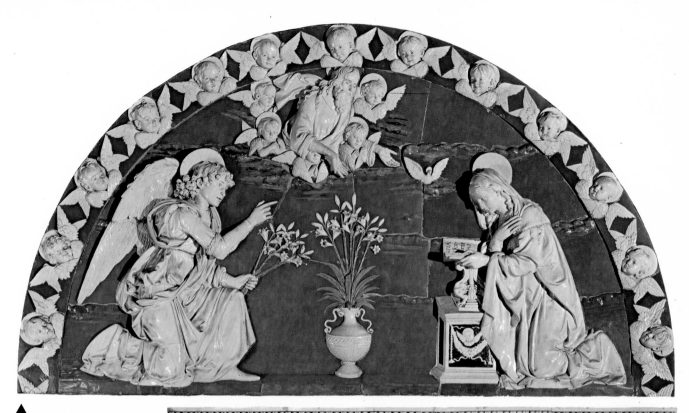

▲

ANDREA DELLA ROBBIA
(ca. 1470; 5' × 9'4";
enameled terracotta)
Annunciation
Hospital of the Innocents
Florence

▶

ANDREA DELLA ROBBIA
(1470-1480; 6'10" × 6'10";
enameled terracotta)
Annunciation
Monastery of La Verna
La Verna (Arezzo)

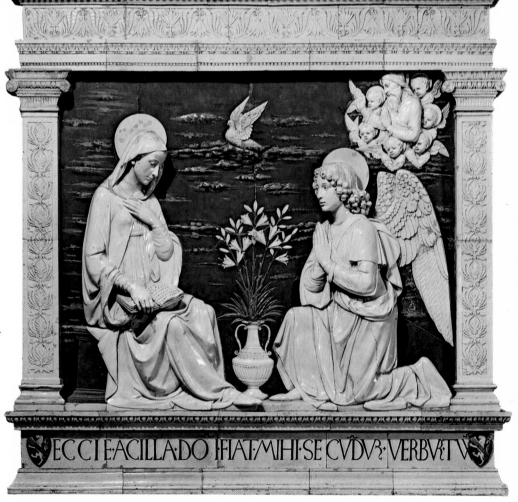

◀

ANDREA DELLA ROBBIA
(1463-1466; 3'3" diam.;
enameled terracotta)
Putto
Hospital of the Innocents
Florence

51

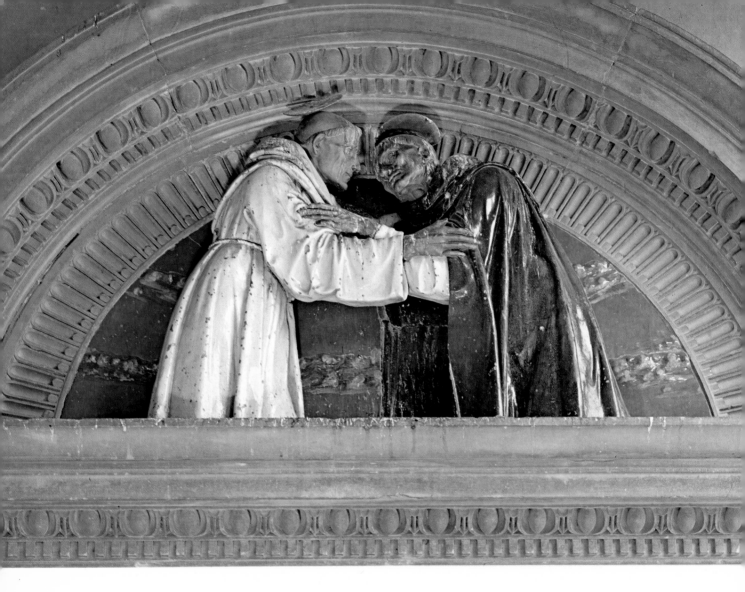

▲
ANDREA DELLA ROBBIA
(ca. 1493; 4'7" × 8'10";
enameled terracotta)
Meeting Between
St. Francis and St. Dominic
Hospital of St. Paul
Florence

▶
ANDREA DELLA ROBBIA
(5'1" × 4'11";
enameled terracotta)
Visitation
Church of
San Giovanni Fuorcivitas
Pistoia

52

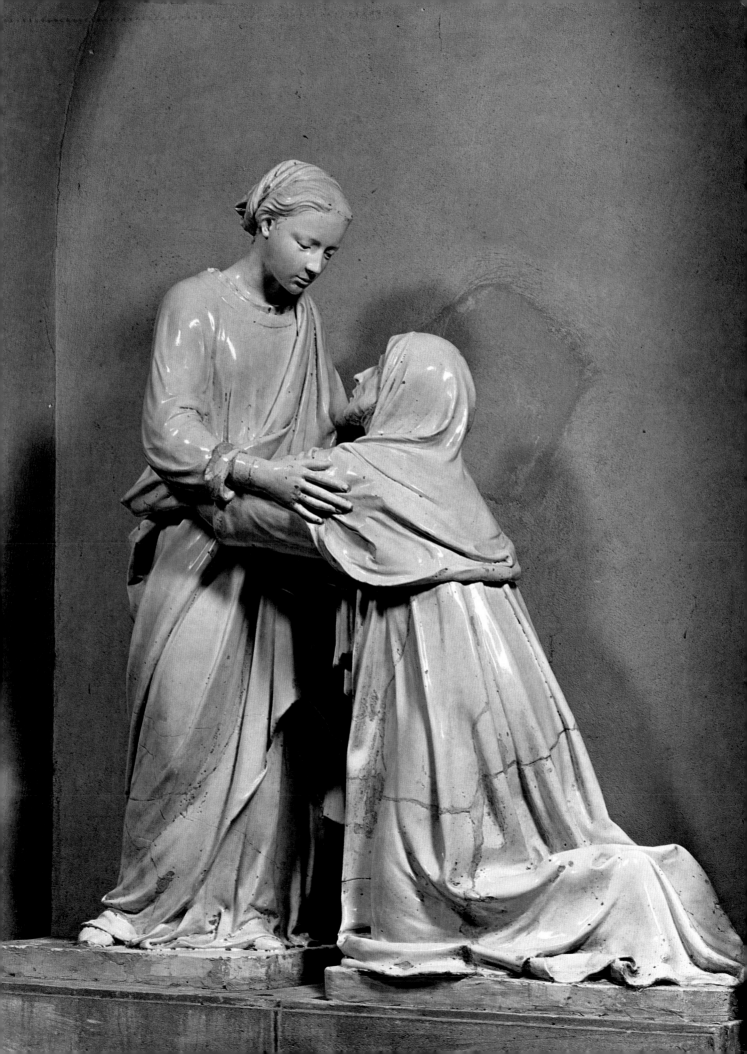

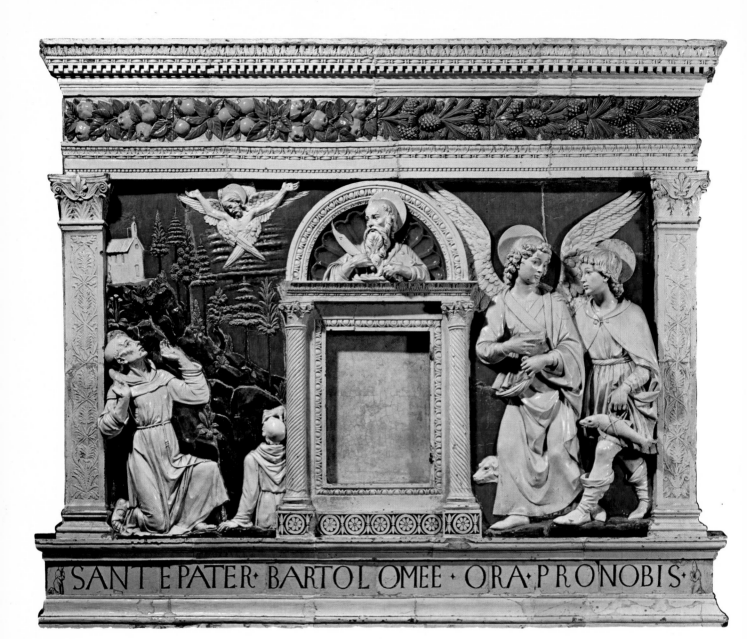

SANTE PATER · BARTOLOMEE · ORA · PRO NOBIS ·

▲
ANDREA DELLA ROBBIA
(1500-1510; 6'6" × 8';
enameled terracotta)
Tabernacle
Museum of Santa Croce
Florence

▶
ANDREA DELLA ROBBIA
(1'1" high; enameled terracotta)
Portrait of a Boy
National Museum (Bargello)
Florence

54

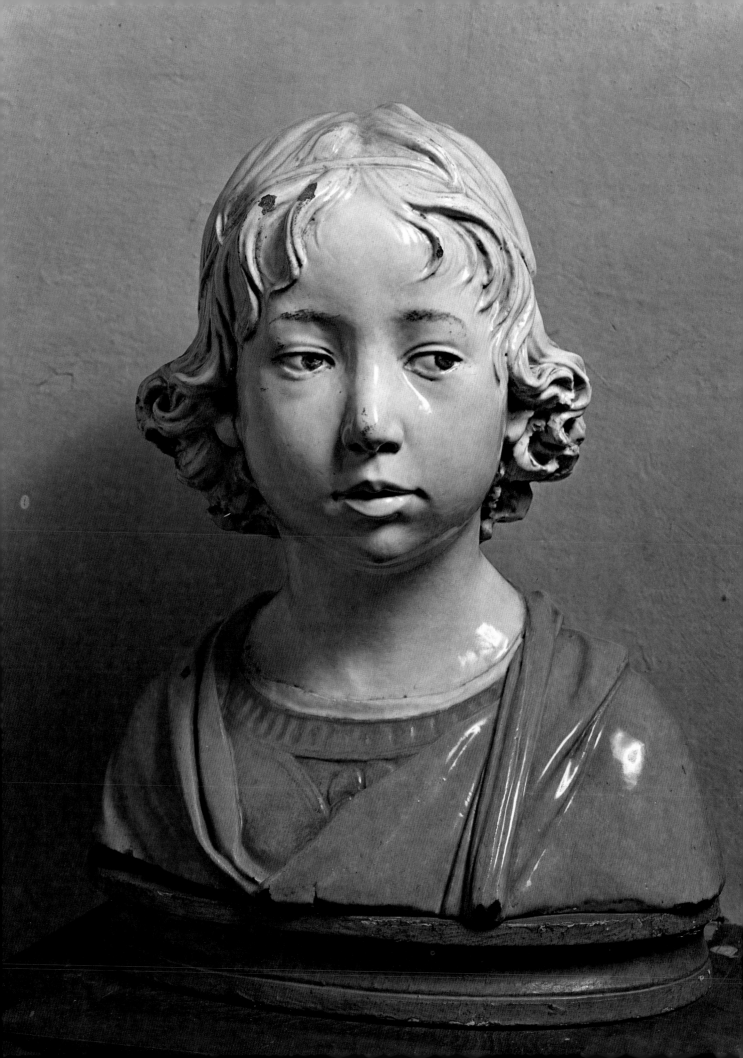

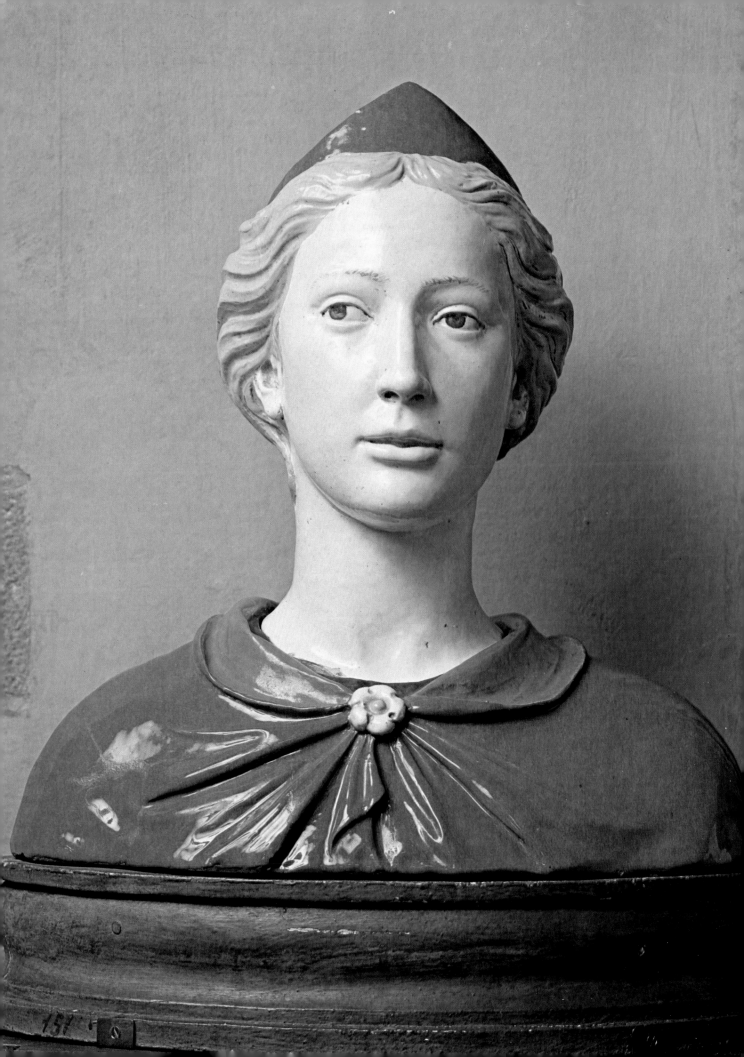

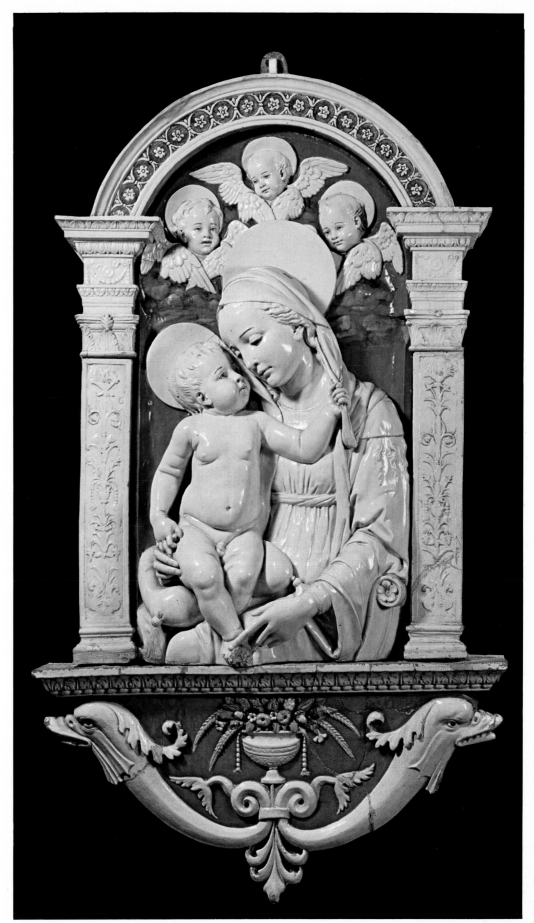

▶

ANDREA DELLA ROBBIA
(ca. 1500;
enameled terracotta)
Madonna of the Cushion
National Museum (Bargello)
Florence

◀

ANDREA DELLA ROBBIA
(1470-1480;
enameled terracotta)
Portrait of a Lady
National Museum (Bargello)
Florence

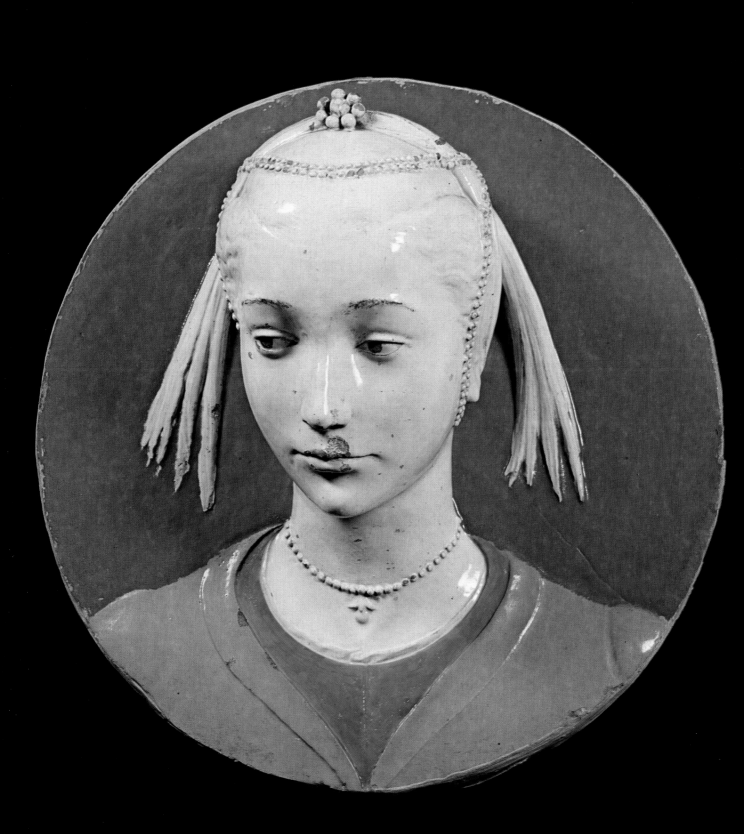

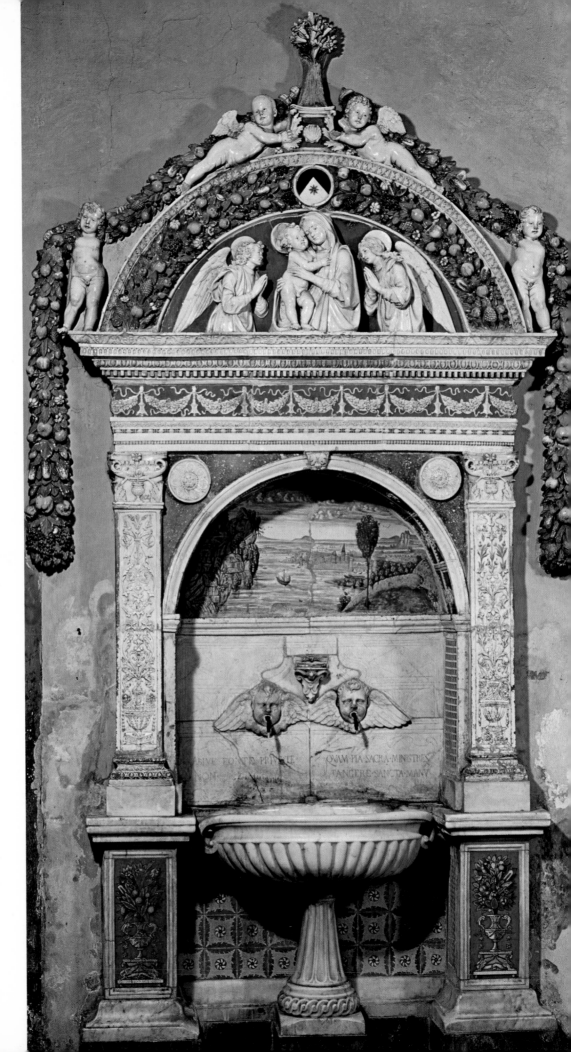

GIOVANNI DELLA ROBBIA
(1497; 13'6" × 7'8";
enameled terracotta)
Lavabo
Sacristy of the Church
of Santa Maria Novella
Florence

ANDREA DELLA ROBBIA
(1470-1480; 1'6" diam.;
enameled terracotta)
Portrait of an Unknown Girl
National Museum (Bargello)
Florence

59

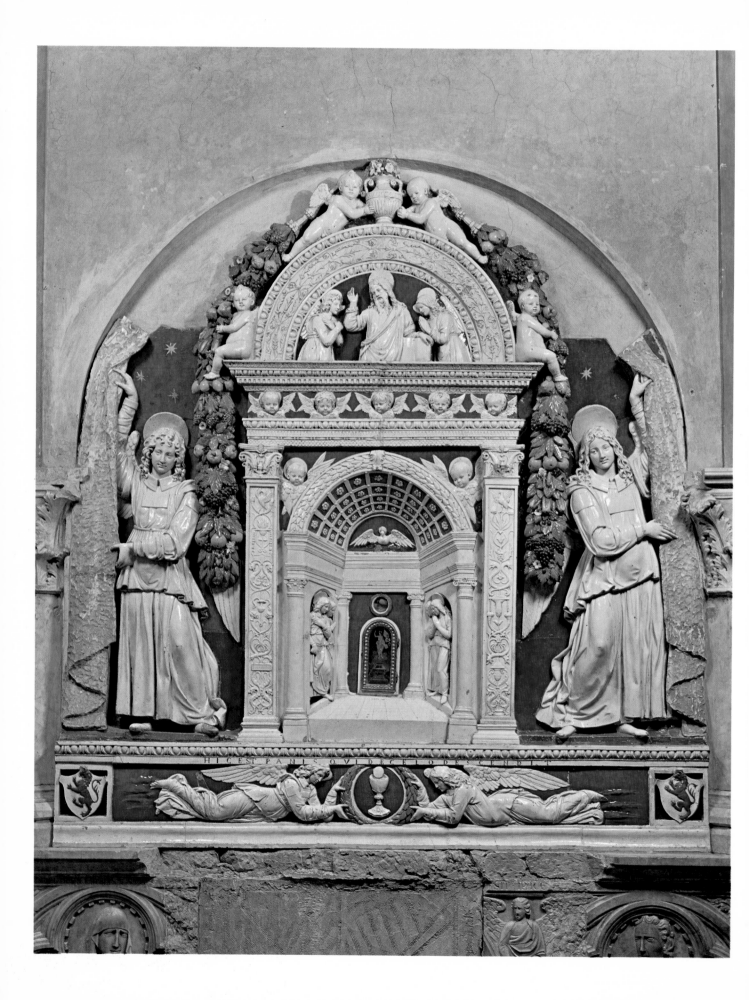

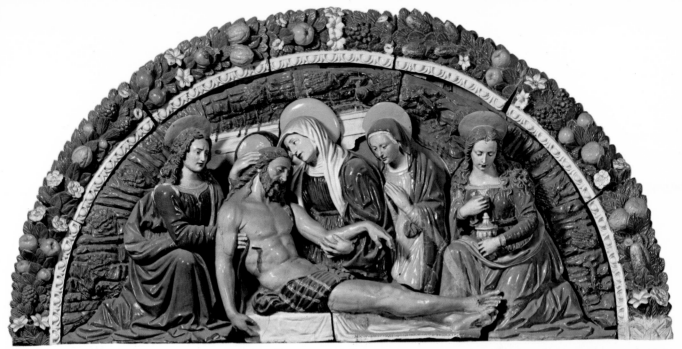

▲
GIOVANNI DELLA ROBBIA
(1521; 2'11" × 6'7";
enameled terracotta)
Deposition
National Museum (Bargello)
Florence

▶
GIOVANNI DELLA ROBBIA
(ca. 1510; 4'7" × 3'7";
enameled terracotta)
Ascension
National Museum (Bargello)
Florence

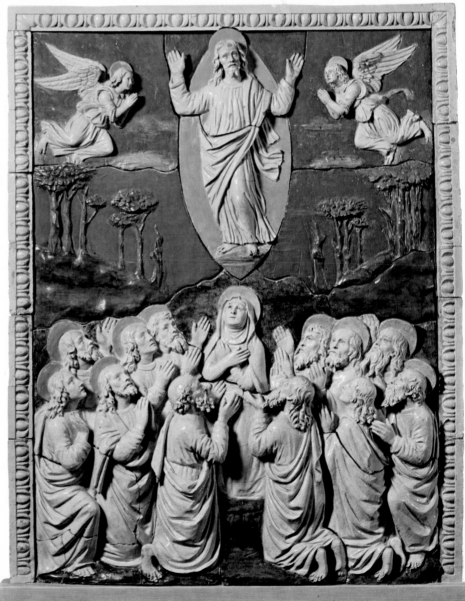

◀
GIOVANNI DELLA ROBBIA
(1500-1510; 8'10" × 7'10";
enameled terracotta)
Tabernacle
Church of Santissimi Apostoli
Florence

61

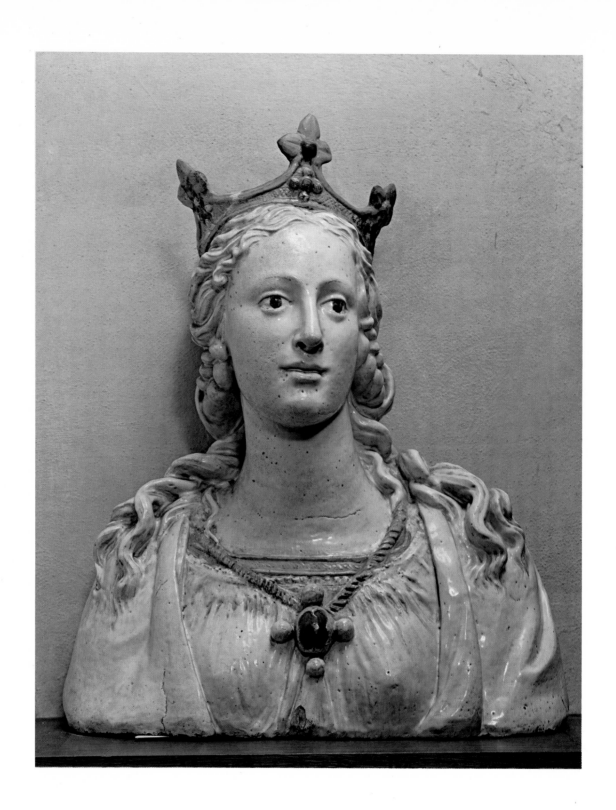

▲
GIOVANNI DELLA ROBBIA
(1520-1530; 2' high;
enameled terracotta)
St. Ursula
National Museum (Bargello)
Florence

▶
GIOVANNI DELLA ROBBIA
(ca. 1520;
enameled terracotta)
Medici — Bartolini Salimbeni
Tondo
National Museum (Bargello)
Florence

62

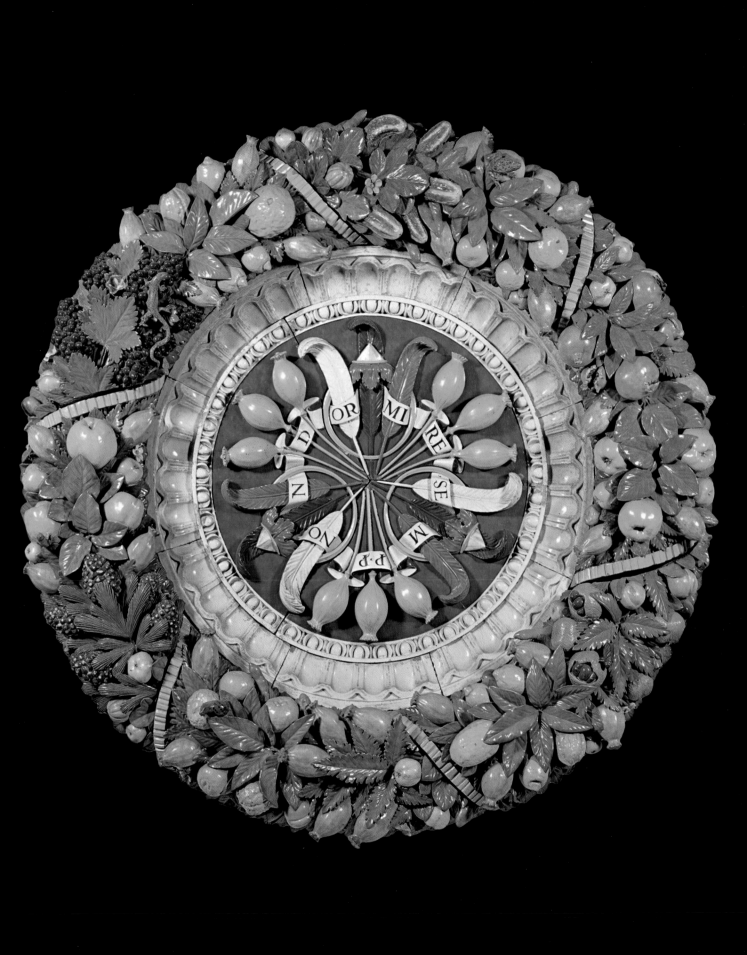

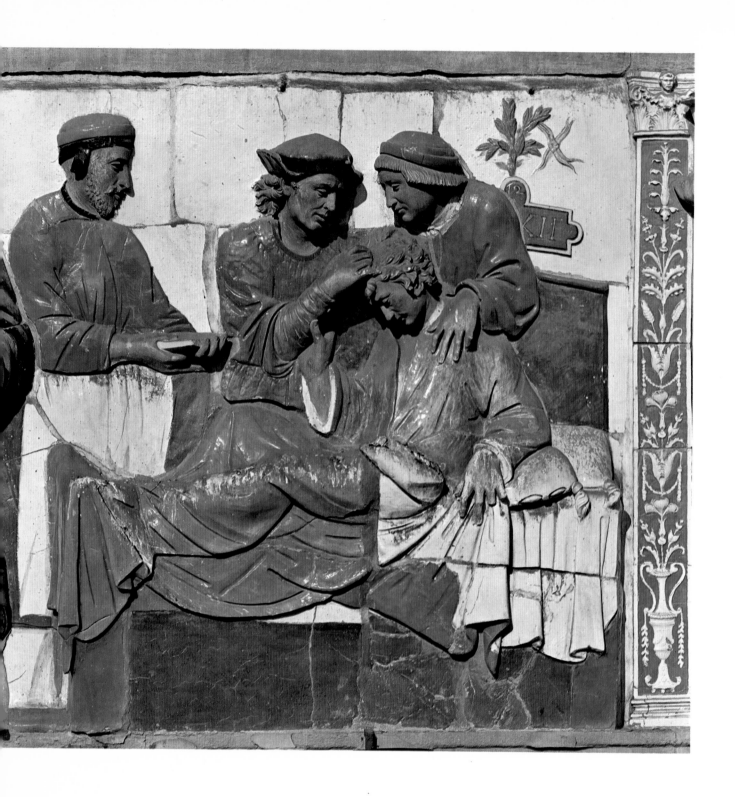

GIOVANNI DELLA ROBBIA
(1525-1529;
enameled terracotta)
« Visit the Sick »
Hospital 'del Ceppo'
Pistoia